# A GUIDE TO PREPARING YOUR PORTFOLIO

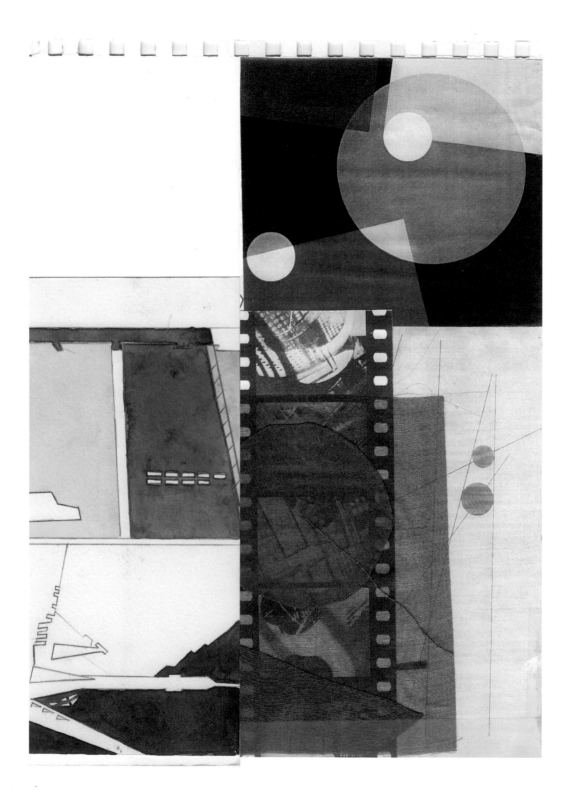

**Jay McCauley Bowstead**

# A GUIDE TO
# PREPARING
# YOUR PORTFOLIO:
## CONTEMPORARY SOLUTIONS

A & C Black • London

## ACKNOWLEDGEMENTS

I would like to thank my father John Bowstead for his integral part in helping me to conceive of, plan and write *A Guide to Preparing Your Portfolio* and for his expertise and advice throughout the process. This book would have been impossible without the many designers, artists, academics, agents and others who not only provided me with images from their portfolios but also took time to talk to me about their work and experiences. I am immensely grateful for all of their contributions.

In particular, I would like to acknowledge the contribution of Jayne Helliwell 1984–2010, whose death has deprived the world of a unique creative talent.

First published in Great Britain in 2011
A & C Black Publishers Limited
36 Soho Square
London W1D 3QY
www.acblack.com

ISBN 978-1-408-1436-0

CIP Catalogue records for this book are available from the British Library.

Book design by Penny Mills
Cover design by James Watson

Printed and bound in China.

This book is produced using paper that is made from wood grown in managed, sustainable forests. It is natural, renewable and recyclable. The logging and manufacturing processes conform to the environmental regulations of the country of origin.

**Frontispiece:** An image from the sketchbook of Jay McCauley Bowstead using collage, paint and appliqué fabric.
**Illustrations:** All images by Jay McCauley Bowstead or courtesy of the artists, unless otherwise stated.

# CONTENTS

Acknowledgements 4

Foreword 6

Introduction 8

1 You and your portfolio 11

2 Presentation, from analogue to digital 26

3 Portfolios for education 68

4 Specialisms 104

Communication (Illustration, Photography and Graphic Design) •
Fashion and Textiles • Contemporary Craft • 3D (Industrial
Design, Interior Design and Architecture) •
Contemporary Art, 3D

Index 160

# FOREWORD

It's about time a book like this became available as I believe many talented 'Creatives' are being overlooked because they don't know how to market themselves. Clients don't have time to point out what you are doing wrong so they just move onto the next one, if you don't get their attention.

Over the past ten years I have witnessed, first hand, how the Web has revolutionised the way that Creatives present their work in terms of digital Vs physical folios. I wouldn't say one has necessarily replaced the other, more that they are used in different ways. A website or digital portfolio is essential to make it immediate and accessible, but in my view the physical portfolio is still very important as it gives the work a much more tangible feel, given that much of the work ends up in print.

As an agent I am responsible for the portfolios of some 30 artists as well as viewing 100s of sites every month of illustrators hoping to be represented by us. I have experienced many different reactions to the various ways in which our artists are presented and can't stress enough the importance of getting it right. In my experience clients do not take kindly to being shown images on a laptop if you are seeing them face to face, as they can just look online to see digital images.

It's now so easy to set up a website and as a result the pool from which to choose has become saturated. Many clients tell me that this makes them retreat into their comfort zone, using the people that they know. They are simply overwhelmed with choice.

More is expected of us than ever before as we try and stand out against the rest, so all the more reason to invest almost as much time in the presentation, as you do in the work itself. If someone stumbles across your website or you drop off your work rather than having a proper portfolio meeting, you won't be able to explain the content and why it's there. A good portfolio, illustration or piece of design photography needs no explanation; it's your creative voice that needs to be heard! You are not

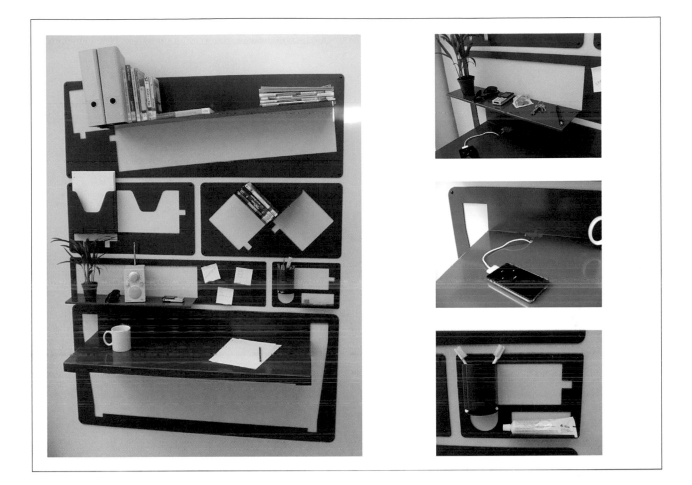

always going to be there to explain, so the work needs to stand for itself.

Recently we changed all our portfolios over to brand new ones simply re-vamping them using many of the same images and noticed that more work came in from meetings as a result.

The manner in which your work is presented is vital and I believe the practical, logical advice given in this book is absolutely essential and could be the difference between a successful career or a wasted degree!

Stephanie Alexander-Jinks, 2011

*Magnus Petterson's presentation explains the use of his office space product using various props and close-up images.*

# INTRODUCTION

As any artist or designer can attest, putting together a portfolio can be a stressful and confusing experience. How can you condense years of work and experience into a slim folder? How do you communicate your identity as an artist or designer? And how do you demonstrate your creative and technical skills, while assuring that the portfolio hangs together coherently and logically?

Drawing on the experiences of professionals, employers, agents and academics working across a broad spectrum of contemporary art and design practice, this book aims to provide a framework around which to build, structure and present a body of work. Images from the portfolios of various practitioners illustrate how artists and designers document and present their work, while quotations and case studies ground key ideas in the real experience of professionals.

Reflecting the increasing popularity and importance of websites, PDFs and blogs, which many practitioners now use in addition to traditional folders, we explore how digital portfolios can be used to promote your practice effectively. More generally, we consider how form and medium are used to mediate and frame the content of a portfolio, while also discussing how context – corporate or independent, traditional or contemporary, professional or academic – affects the way you edit and present your work to achieve the best possible result.

In the fast-moving world of contemporary design and art, practitioners increasingly operate in a multi-disciplinary manner. It is particularly common for those working in a freelance capacity, independently or for a small start-up to work across two or more related fields. For example, illustrators may find themselves producing typography and layouts, while painters might develop artists' websites to supplement their studio work. Similarly, designers and artists often find themselves moving from one specialism to another related field over the course of their careers. Recognising this fact, this book features practitioners from a broad range

*Sarah Kelly's 'Saloukee' jewellery is created using innovative paper manipulation techniques: pleating, puncturing and laser-cutting. Photo: gemmadewson.com.*

of specialisms and offers strategies to reflect diversity and breadth in your practice while retaining coherence. While numerous examples of presentational devices and approaches to editing and structuring your work are given, we do not attempt to prescribe a narrow restrictive formula to assembling a portfolio. Instead, we aim to provide a framework around which to build a portfolio that is highly personal and tailored to your unique needs as a practitioner.

The book is broken down into four major sections:

## Chapter 1: You and your portfolio

This section discusses using your portfolio to communicate your sensibility and creativity: it deals with how a portfolio reflects your individual practice, while focusing on the realities of professional art and design. We look at how to focus your book to make it appropriate to particular applications, and how to use a portfolio to aim for particular positions and opportunities within your field.

## Chapter 2: Presentation, from analogue to digital

Using examples drawn from the portfolios of various artists and designers, this chapter considers how different approaches to presentation, including using text and graphic devices, can affect the way your work is perceived. We deal with choosing an appropriate form in order to effectively present and promote your work, whether that is a website, a traditional folder or a combination of different approaches. We also discuss using order and editing to produce a coherent portfolio that is easily understood, and how to adapt the overall look and feel of your portfolio to make it appropriate for a particular area of your field or market.

## Chapter 3: Portfolios for education

This chapter focuses on portfolio applications to art and design courses and is broken down into five thematic sections. The first is about flair and the importance of communicating a distinctive creative voice; the second considers cultural context, awareness of contemporary and historical art and design, and the ability to demonstrate the influence of other practitioners on your work. The third section deals with technical ability: the development of specialist skills appropriate to your work and level of study, and the importance of core skills in drawing, colour, research and materials. Process, or how to demonstrate the development of an initial concept throughout a project, is the theme of the fourth section. The final section deals with the demands and expectations of portfolios in art and design education according to level of study.

## Chapter 4: Specialisms

This chapter gives an overview of the major specialist areas of art and design, broken down into graphic design, illustration, photography, fashion design, textile design, fine art, industrial design and interior design. The chapter deals with the conventions of portfolio presentation and content by field, outlining the expectations of professionals and employers in each area, while offering an insight into the principal concerns and themes of the various specialisms.

# YOU AND YOUR PORTFOLIO

A good portfolio is coherent as a body of work: it holds together. Most importantly, it communicates who you are as an artist or designer, how you think, what makes you tick and what your creative and intellectual concerns are. In order to build a robust, coherent portfolio, it is necessary first to develop a strong sense of yourself and your practice.

Successful artists or designers are people with a strong understanding of their work. They are able to articulate and communicate their creative concerns, and to understand which themes, ideas and approaches are important to their practice. A portfolio is essentially a promotional tool. In order to promote yourself effectively, you need to develop a clear sense of what you are about.

For an aspiring creative, a unique 'handwriting' or approach is essential in differentiating yourself from your contemporaries and offering a freshness of vision more experienced practitioners may lack. Before you start putting together or re-presenting your portfolio and choosing or rejecting pieces of work, consider what you want to say about yourself as a practitioner. Interviewers will find a portfolio with a strongly defined identity more memorable, interesting and distinctive. Avoid the inclination to be all things to all people, and consider what you are really passionate about as an artist or designer.

When you start putting together or reworking your portfolio, the temptation is to become absorbed in a flurry of activity. When taking a written exam, you are advised to look over all the questions first and then plan how you will approach the paper. Of course you are busy and have a lot of work to do, but before you start editing and re-presenting your portfolio, it may be a useful exercise to write a short statement. Define in words what your key concerns are, list your strengths, what skills you want to highlight in your book, what you want to achieve in

your career. By considering these questions, you will be able to approach your portfolio much more confidently.

In future chapters we will talk more specifically about presentation, promoting your practice and other issues involved in producing a portfolio. But presentation and promotion are not activities that should be undertaken as an afterthought: what your strengths are as an artist or designer, what skills you have to offer and what you want to do will dictate the way you build and present your portfolio.

## Marina South, fashion designer

'I think conveying a strong personal style can often be more important than technical skills and even design. You can be a really competent designer technically, but if the interviewer doesn't get what the story is about, what the look is, what the style is, then your designs don't really make sense. Sometimes I design really simple garments that are all about a certain way of dressing; the way that I present the work, my mood boards, fabric choice and the feeling I convey in the drawings, it's all got to work together to communicate this style. Ultimately, someone who is going to employ you is going to employ you because you convey a really strong sense of who you are in your work and because you are bringing a new angle to what they do already. My designs aren't necessarily complex or clever, but they are stylish — at least I hope so. I've worked at the designer level and for the high street, and in both settings employers liked the fact that my portfolio had a strongly definable style.'

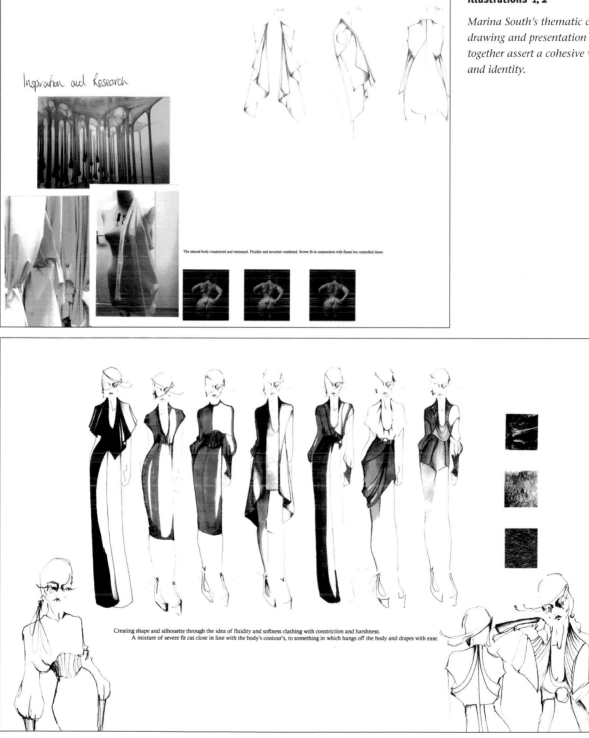

Inspiration and Research

The natural body constricted and restrained. Fluidity and structure combined. Severe fit in conjunction with fluent but controlled drape.

Creating shape and silhouette through the idea of fluidity and softness clashing with constriction and harshness.
A mixture of severe fit cut close in line with the body's contour's, to something in which hangs off the body and drapes with ease.

**illustrations 1, 2**

*Marina South's thematic choices, drawing and presentation work together assert a cohesive vision and identity.*

# Mark McKay, product and furniture/interior designer

'Interviewers often comment on the use of humour in my portfolio. Although in this project I was interested in problem solving, my approach was also deliberately tongue-in-cheek. This playful attitude is integral to my sensibility as a designer; in addition to having robust technical and presentational skills, I think it's important for graduates to demonstrate their individuality and personality in a portfolio.'

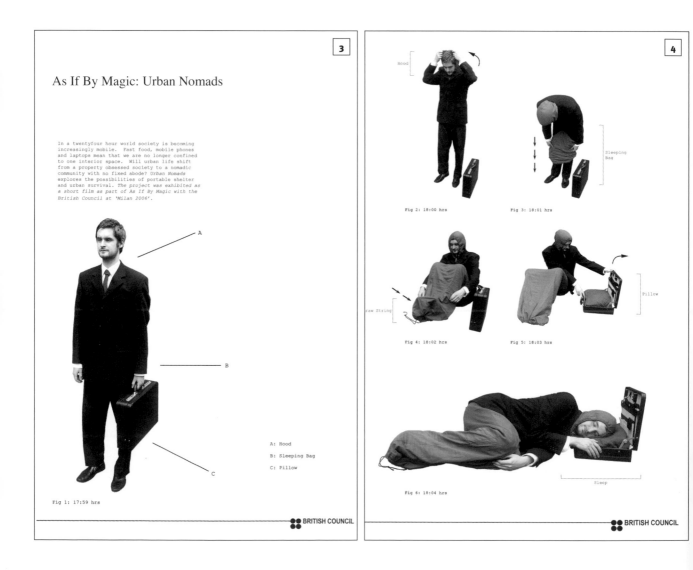

**3**

### As If By Magic: Urban Nomads

In a twentyfour hour world society is becoming increasingly mobile. Fast food, mobile phones and laptops mean that we are no longer confined to one interior space. Will urban life shift from a property obsessed society to a nomadic community with no fixed abode? Urban Nomads explores the possibilities of portable shelter and urban survival. The project was exhibited as a short film as part of As If By Magic with the British Council at 'Milan 2006'.

A
B
C

A: Hood
B: Sleeping Bag
C: Pillow

Fig 1: 17:59 hrs

●● BRITISH COUNCIL

**4**

Hood

Fig 2: 18:00 hrs

Fig 3: 18:01 hrs

Sleeping Bag

Draw String

Fig 4: 18:02 hrs

Fig 5: 18:03 hrs

Pillow

Fig 6: 18:04 hrs

Sleep

●● BRITISH COUNCIL

# APPROACHING PROFESSIONAL PRACTICE

Agents and potential employers will often ask what you see yourself doing in a few years' time. This is an important question, and one you should ask yourself seriously (preferably before you find yourself in an interview setting).

Inevitably, your particular sensibility will make you more suited for some areas of your field than others. Don't give in to the temptation to produce a portfolio that 'covers all the bases' in the belief that this will make you more employable or your work more likely to be exhibited. Instead of playing it safe, you may be jeopardising your chances. It is essential to research what jobs, positions and opportunities exist in your area of art or design. For example, when launching yourself as an artist, it pays to be very aware of what type of work galleries are showing and at what level: do they feature very established names or more up-and-coming artists? It makes sense to approach galleries which are appropriate to your experience and level of development and where you identify with the choices of the director. Equally, if, for instance, you are passionate about ornate and luxurious interior design, it is not sensible to apply to an architectural practice that deals mostly with hospitals and public buildings. In a crowded marketplace, you need to be quite specific about aiming your work in a particular direction. Interviewers want to see a confident portfolio that demonstrates that you have made a conscious decision to pursue a particular field.

Before you start putting together your portfolio, you should consider what you hope to achieve. Clearly, different types of portfolios will be appropriate in different settings: up-and-coming artists who are trying to promote their practice to independent galleries should not present their work in the same way as someone who wishes to enter the field of art therapy, or someone applying to work as a community artist in a deprived area. In the same way, the portfolio of a fashion designer with a casual, sporty sensibility would necessarily differ from one who wishes to work in formal tailoring, or from a fashion graduate who wants to go into trend forecasting. An illustrator who is focused on editorial work for newspapers and magazines would present a different portfolio from a children's book illustrator, and so on.

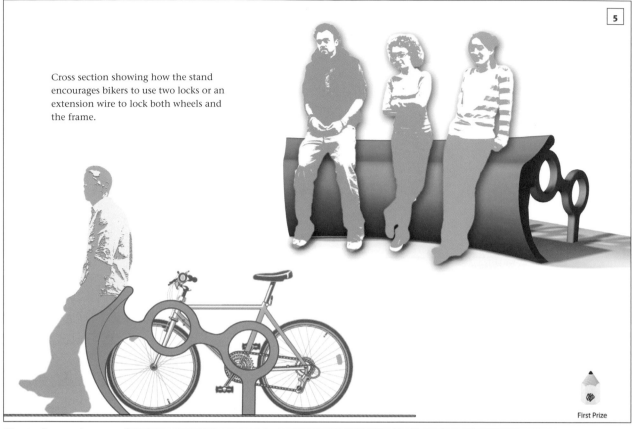

Cross section showing how the stand encourages bikers to use two locks or an extension wire to lock both wheels and the frame.

**5**

First Prize

**Illustrations 5, 6**

*An original concept by Magnus Pettersen, street furniture designed to prevent bicycle theft. Illustration (above) and model (right).*

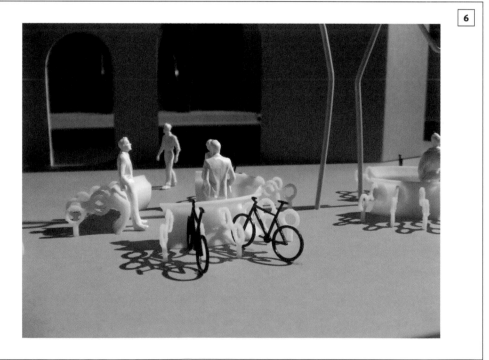

**6**

**Out of Site, Out of Mind** [7]

In a world where advertising and decoration
mean we are constantly bombarded with visual
information, it can often be hard to think.
This hectic world can be restricted to one
point in time through design. Two worlds
created by one product; one side a visual
feast, the other a calming visual void.

[8]

270°     0°     45°

135°     180°     225°

Laquered plywood Chair
Upholstered seat
Available in a variety of
patterned finishes
W40 x H80 x D39
£65

English Rose     Toile de Joue     Violet Damask

el ultimo grito

### Illustrations 5, 6, 7, 8,

*These projects were created by two young practitioners with very similar training in product and furniture design, one of whom now works mainly in industrial design while the other specialises in interiors and shop-fittings of designer shops. Illustrations 5 and 6 feature street furniture designed by Magnus Pettersen: notice the difference in aesthetic and intent from Mark McKay's more decorative furniture design in illustrations 7 and 8. The interests and emphases of the two projects are obviously divergent. In designing a product that aims to prevent bicycle theft (see left), Magnus is concerned with problem solving, behaviour and interaction with urban environments, while Mark's interests (above) are more focused on creating a visually engaging, playful design with a strong, quirky aesthetic.*

At the beginning of your creative career, it is acceptable and even expected that you will work in a variety of settings, seizing any opportunities, internships or commissions that might come your way. You may be presenting a body of work that is quite diverse, but by including projects that are tailored to a specific position or application, you can demonstrate how your previous experiences have contributed to your creative practice. Think about your portfolio as telling a story about your skills and experience and who you are. There may be a range of different projects in your portfolio, but there should be absolutely no doubt that they are all the work of the same person.

A successful portfolio presents work so that it seems coherent and as relevant as possible to the interview or scenario in question. Freelance designers, illustrators and others who work across related fields often have two portfolios, or a number of projects that can be slotted in and out of their books depending on the context of the interview. In the case of a practitioner who has two very distinct bodies of work, for example children's book illustration and portraiture, or greeting card illustration and knit swatching, it is preferable to present these two activities in separate portfolios, or perhaps to divide the portfolio in two. You are not going to be presenting your knit swatches to the same companies as your greeting card designs, so don't show both bodies of work together unless you are specifically asked to (if requested, you could perhaps give a link to your website instead). Remember that interviewers need to have a clear picture of who you are and what you can do.

## Ralph Dorey, artist/sculptor

'I would present my portfolio quite differently depending on whether I was showing it to a gallery or in a teaching or community-based context. For a teaching job, I'd want to show a range of technical skills in my work, to communicate an inspiring, exciting tone in my work, but I'd also show images of students' work, and a few images of projects I had done with people before, which showed a broad range of community and teaching projects I've led or been involved in.

If I were presenting work to a gallery owner, I would be very hands-off and delicate in the way I approached them and then in the way I present and

talk about my work, because gallery owners tend to scare easily. I would present between three and five images of recent work, not too many because you want to leave space for discussion. I'd also give them a project statement to convey some of the key ideas that I'm dealing with in my work. Obviously how elaborate your statement is and what form it takes depends on the persona you want to put across. But as I make it, I don't want to be the critic of my own work, so I tend to avoid getting into discussions where I'm analysing the techniques I've used.'

An important thing to keep in mind is that interviewers want to see proof in your portfolio that you will be able to deliver the goods. If you are applying for a position as a designer for a commercial brand, you need to demonstrate an understanding of that market and an ability to design a product that would sell in that context. Perhaps this sounds obvious, but applicants often present work imagining that an interviewer will be able to see how it could be adapted to a different brand or marketplace. Most of the time, an employer is not willing to make this leap of the imagination. This doesn't mean you have to take out or rework all your previous projects, but you need to show a reasonable amount of work that is directly applicable to the interview in question. Whether you are a designer or an artist, your portfolio needs to demonstrate to the interviewer that you are suitable for that specific position, that you have researched the institution or company and made an informed choice to apply to it. Artists in particular need to be aware of the kinds of work being showcased in galleries, at art fairs and in various publications. If you are starting out in your career, there is no point attempting to approach a gallery that only shows the work of artists with an extensive track record. Writing letters, CVs and sending out packages is a time-consuming and potentially expensive process: it pays to be particular about who you attempt to woo.

## Skill sets

As well as communicating your sensibility to prospective employers, your portfolio should help them appreciate the range of skills you have. These days, most graduates in art and design are expected to be able to use Photoshop, Illustrator and other programs related to specific fields, for example AutoCAD and Vectorworks in industrial design. However, over the past few years traditional skills and a notion of craft have become much more important across art and design practice. Drawing, hand-rendered type and three-dimensional construction skills are prized precisely because they have become increasingly rare. Demonstrating a range of contemporary and traditional technical skills can be a winning formula, but these skills will differ between disciplines and individual practitioners.

Equally important are a range of conceptual skills: developmental work, research, sketchbooks and mood boards demonstrate an ability to think through and adapt an initial idea. Particularly in graphic and industrial design, practitioners need to demonstrate an ability to analyse social, environmental and informational problems and to develop innovative design solutions.

Whether presented in the form of a sketchbook, a mood board, a series of drawings and photographs, or even as an artist's statement, evidence of research is also important in demonstrating cultural awareness. Graphic designers, illustrators, fashion designers and others often refer to – or appropriate – the semantics of other artistic forms or historical movements. Irrespective of your discipline, an awareness of art, history, literature, design and culture is part of being a professional.

## Kirsten Elliott, graphic designer

'As a designer, I'm very much concerned with process and problem solving. For me, a graphic design portfolio definitely needs to demonstrate strong conceptual skills, which means an ability to come up with innovative solutions, as well as cultural awareness and creative energy. My ideas are sparked through a process of brainstorming, and then research and development using sketchbooks and mood boards. I work through

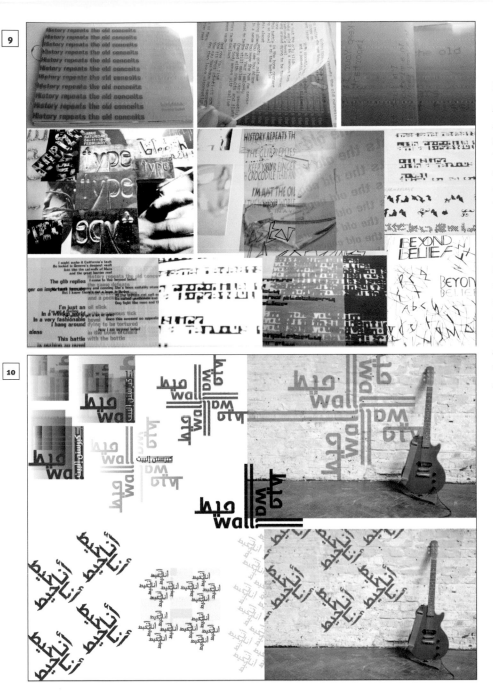

### Illustrations 9, 10, 11, 12

*In her developmental work, Kirsten Elliott plays with ideas in a free and experimental way, using freehand drawing, collage and printed type. Note how Kirsten's sketchbook work in illustrations 9 and 10 contrasts with the more highly finished aesthetic of her design presentation sheets, illustrations 11 and 12 (see overleaf). This allows clients and interviewers to get a sense of how she has developed and thought through her ideas. In graphic design, problem solving and strong conceptual skills are particularly important.*

various initial ideas before presenting a range of concepts to my client. When you are presenting your book you need to show that you can develop ideas effectively and that you can interpret a brief creatively. So I would definitely recommend taking sketchbooks to interviews along with your folder. Of course, you need to demonstrate high production values and professional presentation, too.'

2008 Commemorative Stamps

Celebrate the revival of the genuine heart and soul of Dubai where early settlement of trade provided the building blocks for creativity and businesses to prosper.
A place that is now growing and adapting in an ever-chaging world, fostering creativity , diversity and interactivity.

**Retrace Revive Relive**
Dubai Creek, A Future Proud of It's Past.

**11**

Up-and-coming artists and designers may feel that they are at a disadvantage compared to more established practitioners, who can point to a proven track record of successful projects or previous positions. The solution is not to attempt to compete on experience alone – although you may be able to point to internships, freelance work or exhibitions you have organised yourself – but rather to emphasise your distinctiveness. As a recent graduate, you can perhaps demonstrate a freshness of vision and an awareness of contemporary culture, music and underground creative scenes that employers and others may be keen to access. For this reason, it is essential to stay creatively active while looking for opportunities in your field, even if that means self-publishing fanzines, collaborating with other young creatives to mount a show or interning for an organisation for which you aspire to work.

**Refresh** in the spirit of Dubai

سوق ديرة القديم
Deira Old Souq

**Retrace** Your Footsteps through History

ممشى السوق القديم
Old Souq Walk

**Retreat** for Relaxation

السيف
Al Seef

Dubai Creek, A Future Proud of its Past. www.dubaicreek.ae

# Fresco

Corporate Typography                Tone of Voice

Where Modernity **Reconnects** Tradition    **Rediscover** the Diversity of Trade

Where Culture **Reveals** Heritage    **Rejuvenate** your Mind, Body and Soul    Where Footsteps **Retrace** History

12

While younger practitioners often find it difficult to break into the creative industries, older artists and designers can feel somewhat at a disadvantage in an industry obsessed with novelty and youth. In this case, the solution is twofold: on the one hand, emphasise that you are grounded in your practice, with an extensive understanding of the discipline that has evolved over your career, along with the development of your technical and creative skills. On the other hand, subtly signal through the presentation of your work – and even in your dress and speech – that you have a contemporary sensibility and remain a dynamic and innovative practitioner. In this way, you can demonstrate an awareness of recent developments in the field that complements your experience and expertise.

While it is of course important to show that you have a range of relevant skills, it is sometimes tempting to adopt a tick-box attitude to your skill set in a portfolio. In some interview settings in particular, you need to demonstrate technical skills applicable to a specific role, for example as an animator or as a website designer. However, in an increasingly competitive market across most areas of art and design, it is not sufficient to simply demonstrate that you are broadly and generically competent. Time after time in portfolios, applicants hide their light under a bushel, particularly if they are confused about what their particular and distinctive skills are. For example, if you are an excellent draughtsman, or someone who knits complex cables out of razor wire, or if you just happen to produce marquetry panels illustrating the miners' strike, you need to sell these skills hard. All too often artists and designers do not highlight and market what makes them interesting and distinctive.

## Summing up

Aspiring practitioners – and even more experienced ones – often tend to think of their portfolios simply as collections of their strongest work, perhaps tidied up a little and put in plastic sheets. Portfolios can exist in a plethora of diverse forms: boxes, hand-bound books and online galleries. However, as we have seen in this chapter, whether or not your portfolio is successful is often a question of how appropriate it is to you and your practice, as well as its ability to perform a range of specific tasks or functions.

The key ideas discussed in this chapter could be characterised as thinking of your portfolio as a tool whose job it is to communicate certain ideas about you, your abilities and the personality of your work. As a creative person, you are probably used to designing, conceiving and developing products that either solve problems or communicate ideas, or do both. Applying the same level of analytical thinking to designing your portfolio and promoting your practice can pay dividends. In the same way, potential interviewers can be thought of as users or consumers of this

end product: what information do they need to get from your portfolio, and how can you tailor your portfolio to suit their specific needs?

To recap, the key functions of a portfolio are as follows:

- To communicate your identity as a practitioner, to articulate who you are and what are you about, and to demonstrate a strong sense of your personal sensibility and your individual practice.

- To indicate where you want to go and what you want to do, to demonstrate that you have realistically considered how to pursue your professional practice in the context of your individual abilities and sensibility, and to aim yourself at particular opportunities, positions or sources of funding.

- To market your distinctive qualities and abilities, highlighting the range of technical, creative and conceptual skills you possess.

# PRESENTATION,
## from analogue to digital

When we think of a portfolio, a large black folder comes to mind – perhaps in dusty cloth-covered board, clutched under the arm of a pastel-stained artist. Today, however, in the professional and competitive world of art and design, portfolios are often highly specialised entities, differing significantly between practitioners and disciplines. And, as you no doubt appreciate, they are as likely to take the form of digitally generated documents as dusty folders.

Nevertheless, while new and innovative forms of portfolio have flourished and diversified in the past ten years, the concept of a traditional folder containing an edited selection of a designer's or artist's work remains important. Traditional portfolios are still widely used across all areas of art and design, and even practitioners who have websites and PDF versions of their portfolio are expected to present a physical folder, book or similar in face-to-face interviews and meetings.

The portfolios of artists and designers working in a professional context are required to be polished and accessible. Professional portfolios tend to be neater, more strictly focused and edited, and physically smaller than the hulking A1 monstrosities so common in art and design education. The most common is the classic designer's portfolio, with which you are no doubt familiar: simple, A3 or A4 in size, usually black or another dark, neutral colour, with clear plastic sleeves inside. These display folders are commonly used in interior design, graphic design, illustration, fashion and product design, and are favoured because they look professional and are light, portable and neat. All folios of this type are fundamentally similar. Typically ring-bound, they have the advantage of allowing the designer to easily slip projects in and out, so that the portfolio can grow and change organically. While one would hope that interviewers

concentrate on the content rather than the cover, the choice of portfolio can convey subtle messages: for example, folios with weird textured covers, prominent manufacturer's logos or ugly bulky zips can have something of a 'craft hobby' look that is best avoided.

As we will discuss later in this chapter, portfolios can take any number of diverse forms. However, for practitioners who wish to present their work as simply and neutrally as possible, a classic portfolio has the advantage of distracting from their work as little as possible.

When you are choosing the form and dimensions of your portfolio, perhaps the most important consideration is how you plan to use the folio in communicating the key characteristics and qualities of your work. For example, Catherine Aitken is a printed textile designer with her own line of print-related products (catherinelouiseaitken.co.uk). Because subtle mark-making and the touch and feel of fabrics are important to her practice, Catherine presents her work in a simple A2 cardboard folder, with drawings and samples loose rather than in plastic sheets. This allows interviewers to appreciate the tactile and textural qualities of her work.

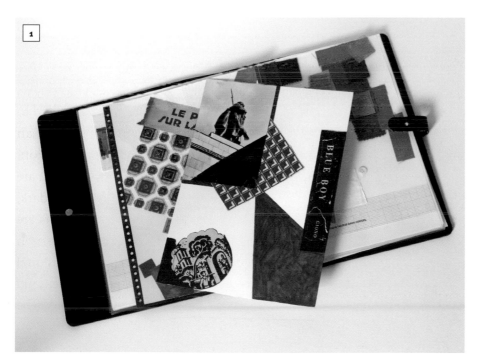

**Illustration 1**

*A classic designer's portfolio, by Jay McCauley Bowstead.*

# Catherine Aitken, printed textile and surface designer

The first part of Catherine Aitken's portfolio is devoted to mixed-media studies, mainly in pencil and gouache. These illustrate how her ideas about colour, mark-making, motif and pattern are initially developed through a process of drawing, painting and experimentation, before becoming resolved designs. Catherine also presents examples of images that have inspired her designs mounted on card; these include her own studies of cityscapes and built environments, as well as images from artists who influence her. The final part of the portfolio is a large selection of fabric samples, each about A2 in scale and not mounted. This section demonstrates how designs on paper have been translated on to fabric. Here, Catherine shows she is able to consider the textural, tactile and structural qualities of cloth and how these interact with the marks and motifs of her print. She also demonstrates an ability to use a variety of techniques and processes, such as different types of dyes, flocking, embroidery, screen printing and digital printing. 'Presenting real samples of fabric rather than photographs is essential if interviewers are to appreciate the relationship between the print and the cloth,' Catherine explains. 'Colour is notoriously difficult to replicate in photographs and the subtleties of the print may be lost. It is also very difficult to communicate texture or, for example, the way in which pattern distorts as fabric moves and wrinkles.'

As we have seen, for some artists and designers presentation may be a simple case of editing and ordering work to represent the various aspects of their practice (more on this later). This alone is often a sufficiently time-consuming and difficult activity, but more complex presentational problems arise for other practitioners. For example, artists and designers who work in three dimensions have to consider how to document their work in a way that takes account of scale, space and context. Similarly, those working in film and video have to present still images in a portfolio in a way that supports and relates to their moving image and time-based work – perhaps by using storyboards, stills and preparatory drawings.

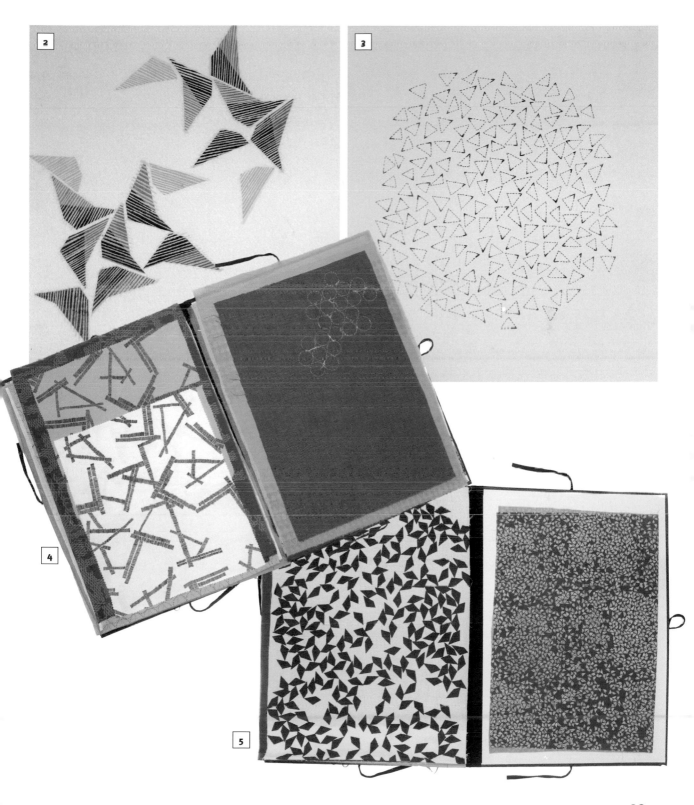

6

### 4.2 Oasis

The Oasis provides social, visual and oral stimulation focussing around a refreshment point spanning the ground and first floor. Words, images and sounds are displayed which may be random or connected to the company brief. They are designed to spark ideas in a informal social setting.

Louvers spiral the front wall which visually connect the Oasis with The Exchange and can be closed for an exhibition experience.

At the end of the day coloured light spills from the Exit Foyer, through the Oasis louvered wall and draws people out of the curved facade of the building.

Users will only leave with a solution to the immediate problem but with the means and intentions to solve future problems

Visual cut through The Oasis within The Exchange

Creativity Gateway...

## Chloe Sharpe, interior designer

Interior designer Chloe Sharpe uses presentation in her portfolio in order to evoke space and to communicate detailed technical information, at the same time employing presentational devices to create a coherent aesthetic and a distinctive personality throughout the folder.

Notice how thoughtfully these A3 pages from the graduate portfolio of interior designer Chloe Sharpe have been composed: dynamic diagonal lines, carefully balanced asymmetry and a subtle, considered use of graphic elements. She has used a consistent project identity composed of a logo, restricted colour palette and other framing devices to create a sense of coherence, which, crucially, avoids being ostentatious or distracting. Chloe has combined hand-drawn, computer-generated and photographic elements to convey a sense of the space she has designed, and the use of text is concise and descriptive, helping to enrich our understanding of the images presented. Chloe's strong approach to visual presentation is particular to her practice

**Illustrations 6, 7**

*Information-rich presentation from the graduate portfolio of Chloe Sharpe. Multiple elements are effectively combined using text and graphic devices.*

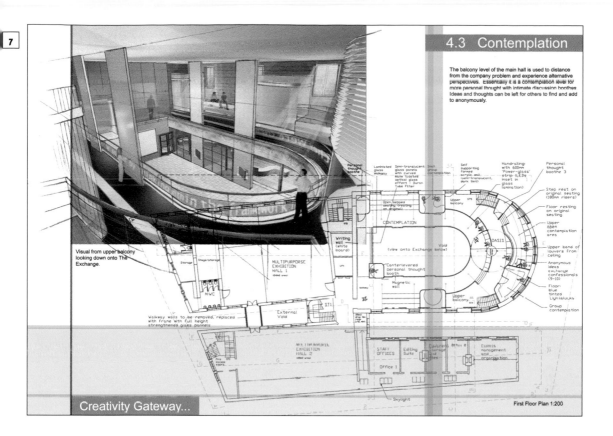

### 4.3 Contemplation

The balcony level of the main hall is used to distance from the company problem and experience alternative perspectives. Essentially it is a contemplation level for more personal thought with intimate discussion booths. Ideas and thoughts can be left for others to find and add to anonymously.

Visual from upper balcony looking down onto The Exchange.

Walkway walls to be removed, replaced with frame with full height strengthened glass panels.

Creativity Gateway...

First Floor Plan 1:200

and individual creative sensibility. However, the principles of this approach – relevance, an understanding of composition, balance and aesthetics, and the use of clear and descriptive text – can be applied much more broadly.

In portfolio projects, presentation is principally a way of framing, explaining and clarifying content. However, we can also think of presentation as a form of content in itself, as the ability to present information in a professional, clear and aesthetically pleasing manner is an integral part of many jobs in the creative industries. In this sense, sophisticated presentation can be as much about demonstrating a necessary skill set as guiding an interviewer through a body of work. In either case, presentation needs to be considered. Too often, an irrelevant surface gloss is applied to portfolio projects that can end up making it more difficult for an interviewer to understand what you and your work are about. It is important to remember that however complex or minimal your approach to presentation, it should always enrich and clarify your work, helping to communicate the key ideas of a piece or project rather than distracting from it.

**Illustrations 8, 9, 10**

*The delicate, hand-rendered work of illustrator and graphic designer Jayne Helliwell is complemented by a clean, minimal, professional approach to type and layout.*

# Jayne Helliwell, illustrator and graphic designer

Like Chloe Sharpe, illustrator and graphic designer Jayne Helliwell uses explanatory text and project titles to help contextualise and clarify her presentation. The overall look of her portfolio, however, is very different from Chloe's. Jayne's idiosyncratic approach combines photography, drawing, collage and hand-written text to produce quirky and sometimes disturbing images. Although she uses a range of design programs, her emphasis is on communicating an energetic, hand-rendered and immediate aesthetic. Jayne's minimal presentation lends coherence to her portfolio while allowing the work sufficient space. It also frames her delicate, hand-drawn compositions in a professional context, demonstrating their appropriateness and relevance to a particular brief.

**8**

Page 2 of 10
22/05/08

Project
Monarcs / Thank God ep

Client
Mashnote records

Masnote Records is a Belgium based label that distribute worldwide. Mashnote asked me to design there latest release, a white 12" complete with inserts.

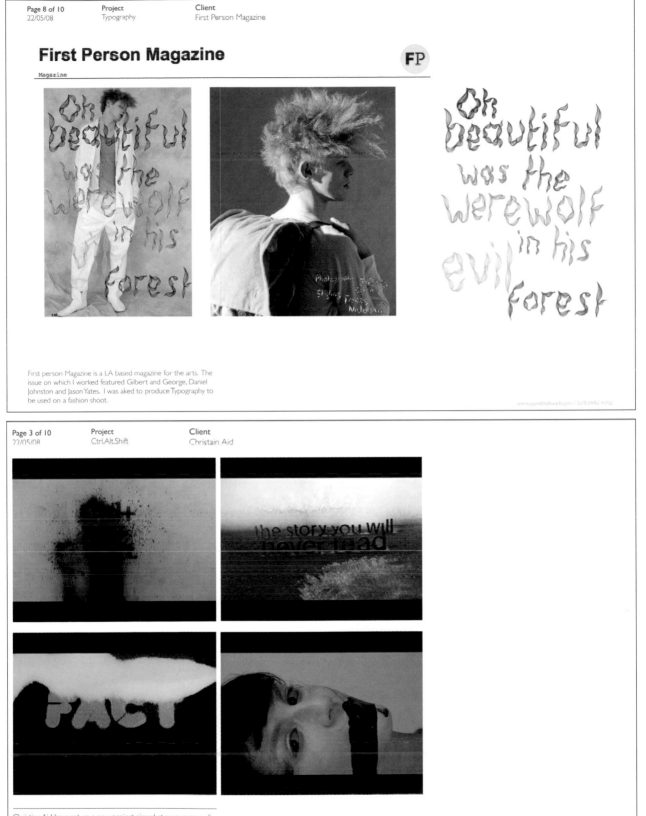

**9**

Page 8 of 10
22/05/08

Project
Typography

Client
First Person Magazine

# First Person Magazine

**FP**

Magazine

First person Magazine is a LA based magazine for the arts. The issue on which I worked featured Gilbert and George, Daniel Johnston and Jason Yates. I was aked to produce Typography to be used on a fashion shoot.

www.jamiehelliwell.com / 079.3440.9782

**10**

Page 3 of 10
22/05/08

Project
Ctrl.Alt.Shift

Client
Christain Aid

Christian Aid have set up a new project aimed at a younger audience internationally called Ctrl.Alt.Shift .The pitch was to make a film that could be personal and creative in terms of production and relate to a theme. We choose Politics in the Media.

In both these portfolios, individual projects with distinct graphic identities sit within a broader, coherent strategy of presentation, unifying the body of work as a whole. In this way, presentation can be used to structure a portfolio and render content more accessible.

It can be very useful to imagine the discussions and responses that pieces in your portfolio are likely to provoke: it is often possible to use projects as a pretext to highlight skills and experiences relevant to the application in hand. It may also be worth considering how you can use the structure and sequence of your portfolio to elicit the conversation you want to have, one that allows you to focus on your skills and abilities. For example, by emphasising how much you learnt as an intern in a particular organisation and showing the interviewer evidence of work you produced in this context, you may be able to skirt over the fact that you have never had a permanent position in your field.

The order in which projects are presented in a portfolio can imply a narrative, or lead an interviewer on a particular journey through your work. The first two projects and the last are commonly thought to be the most important in a portfolio. Whether you structure your portfolio broadly chronologically, in reverse order or according to some other system, it is vital that the first project in your folder is one you feel proud of and can talk about with confidence and authority. In a sense, your first project should demonstrate your aptitude, the second should prove it and the final project should leave the interviewer with a positive overall impression. Most designers and artists will place their most recent work at the front of their portfolios, as interviewers are more likely to be interested in your latest projects. However, this order can be played with to allow you to highlight particularly impressive or relevant projects. Of course, all the work in your portfolio should be of a high quality, but it is certainly sensible to consider which projects are most successful, interesting and relevant to your particular context or application before attempting to impose a structure on the body of work.

As we have discussed in previous chapters, artists and designers may have several portfolios, perhaps designed to be presented in differing contexts, or to distinguish distinct bodies of work from one another.

# Paul Vincett, 3D illustrator

'I do have a physical portfolio, it's a must, and something that always needs to be updated, particularly after any job or commission you've done. But relevance to the job I'm applying for is key, so I have a couple of different versions [of portfolio folders]. My website and an ongoing Flickr account are my constant up-to-date portfolios. Flickr is great to go alongside my blog, I'm constantly updating it to show how productive I'm being and I find it's a great way to spur me on to churn out fresh work.'

Paul Vincett is a 3D illustrator who has also worked extensively as a freelance costume and prop maker. Working across diverse areas of design and craft, Paul is sensitive to the different requirements of these areas, adjusting the way in which he presents his skills and experience to emphasise their relevance to a particular position.

Artist and curator Alastair T. Willey documents his own work and collaborative projects in a number of ways. In the first portfolio, featuring a collaborative project Alastair designed and exhibited at the NEXT art fair in Chicago, illustrations 11, 12 and 13 (see overleaf) are analogue photographs and have been given a certain amount of space on the page. Carefully edited, they have been presented on high-quality off-white paper in a simple but attractive bound book. In contrast, Alastair's documentation of the transformation of TheBunkerGallery, an art space he founded and curated, is in the form of a flipbook (see illustration 14). While both projects are presented in a clean, unfussy and professional manner, the choice of form gives us clues as to how we as viewers are supposed to interact with the portfolio object. The images from the NEXT art fair document a fully realised project in a prestigious context. Therefore, they are presented in a manner that gives the individual images a certain amount of importance – as well as allowing the artist/curator to explain the project as the viewer goes through the document. It also provides the viewer with a sense of the appearance context and content of the exhibition. Conversely, TheBunkerGallery flipbook presents interesting images that document a work in progress: accordingly, the images are given less individual importance, and the form encourages

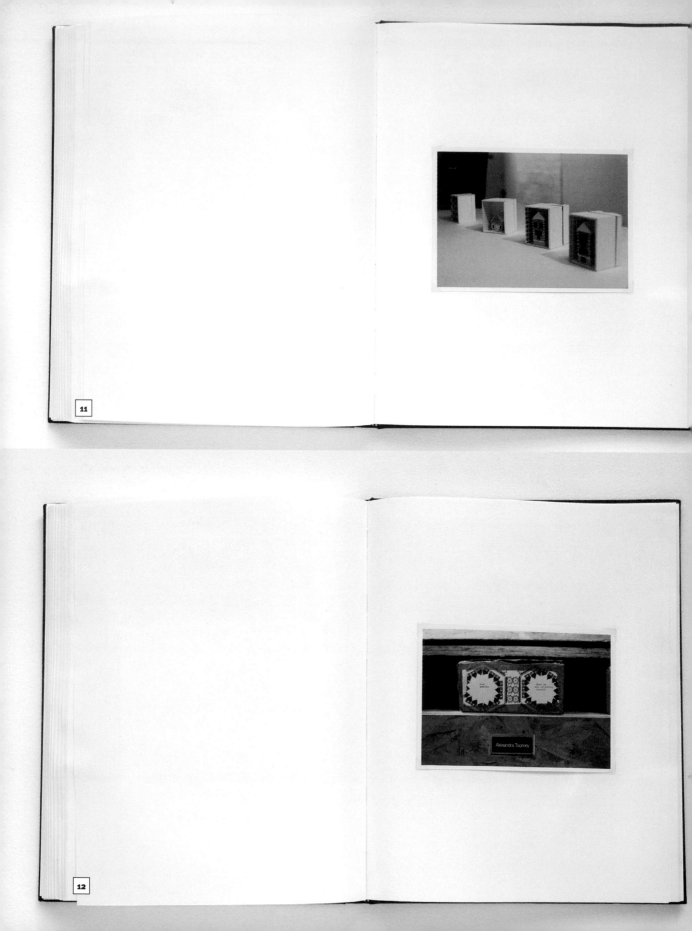

### Illustrations 11, 12, 13, 14

*Artist Alastair T. Willey approaches the documentation of his work in a variety of ways, depending on context and audience. Illustrations 11, 12 and 13 are from an exhibition at Chicago's NEXT art fair curated by Alastair T. Willey. Illustration 14 is a flipbook documenting the creation of TheBunkerGallery.*

the viewer to look through the images quickly. This demonstrates that even when practitioners present their work in an ostensibly simple and neutral manner, they are still making choices about how this work will be viewed and experienced. Interestingly, Alastair also created a website version of the NEXT fair exhibition, again allowing him to mediate the experience of the documented work according to audience and context.

As we have seen in this chapter, you can use different approaches to presentation to frame your practice in particular ways. Doing this successfully requires knowledge of the conventions of your field and, perhaps even more importantly, an awareness of contemporary (and historical) visual culture, as Lloyd Winters, a graphic designer with extensive experience across information graphics, advertising, art direction and website design, explains:

'Good graphic designers locate their practice in a broader cultural context, as well as being aware of trends in other areas of art and design. They have a sophisticated understanding of the semantics of typography, image and layout. This means they are aware of the historical and contemporary associations of using particular techniques or typefaces and of the sort of practitioners who might have employed similar aesthetics or techniques in the past. Each project in a graphic designer's portfolio should look professionally executed and should employ a consistent, coherent aesthetic throughout. The look and finish of a project needs to be appropriate to the organisation or individual it is intended for, and it should relate to the subject, theme or concept it is dealing with. So it is important to consider if the identity you or your client want to communicate is "slick" or "edgy", traditional or contemporary etc. Projects will appear weak if they seem to be unfinished or if they have an unresolved aesthetic with poorly considered type, images or layout.'

As Lloyd Winters suggests, practitioners across the visual arts – not just in graphic design – need to have an understanding of the semantics of various presentational devices. Decisions we make about whether to use a serif or sans-serif typeface, matt or glossy paper, hand-drawn or computer-generated imagery are not neutral: they carry with them a set of references and associations which in turn can be used to manipulate and affect the way in which the viewer understands and responds to your work. This does

not mean you should spend hours agonising over which slightly different off-white paper to choose, however great the temptation. But it is essential to consider what you want to say about yourself and your practice before you start to present your portfolio. And if you are producing a project for another company or organisation, it is essential to consider how to reflect their identity in your approach to presentation.

## PROFESSIONAL AND GRADUATE PORTFOLIOS

Designers generally need to present university projects differently from work produced in industry. Projects produced in education are often presented more graphically, including descriptive text and other graphic devices that lend the project a strong coherent identity. Graduates with limited experience in industry need to prove that they can present work in a professional manner; they also need to convey the concept, themes and concerns of a project efficiently. Briefs and parameters in education tend to be more diffuse and open to interpretation than in professional practice, and are therefore more difficult for an interviewer to understand and relate to the 'real world'. Coming from education into the marketplace of art and design can be a shock: you may think that the ideas and skills you want to highlight in a project are self-evident, but in a commercial context you are often expected to spell things out explicitly. As we have seen, adopting various presentational strategies including motifs, type and explanatory text is an important way of clarifying and contextualising a project.

Conversely, work produced in industry should be reworked and re-presented as little as possible. While a portfolio should always feature pieces that have been edited to create the best possible effect, employers and agents need to understand the nature of the work undertaken in a professional position or work placement. In particular, re-presenting rough work or attempting to prettify technical drawings produced in a professional context may actually distract from the skills and experience you acquired in that capacity.

## Chloe Sharpe, interior designer

'At university, we were encouraged to present projects carefully and concisely, so that the layout of each page in my portfolio was similar to a poster. In this way, readers would be given a good idea of the key principles and design solutions, but would be enticed to find out more. In my graduate portfolio, the formal layout demonstrates graphic design skills that have proved invaluable in my professional career. However, if I were to present a body of my professional work now, I would at times make it feel more free – presenting some projects as works in progress. Perhaps a balance between free ideas in sketch form and resolved solutions professionally presented is key.'

## PRESENTING DEVELOPMENTAL WORK

There is a temptation when putting together a portfolio only to show finished pieces of highly presented work. The danger in this approach is that it can obscure one of the potentially most interesting aspects of your practice: how you arrive at and develop ideas. In the images opposite by fashion designer Marina South and furniture and interior designer Mark McKay respectively, notice how two very different designers specialising in different fields have incorporated developmental work into their presentations. What is interesting about these images is that the designers have managed to communicate how they thought through and explored ideas (in these cases around form and construction) while retaining a consistent, professional and visually engaging approach to presentation. The challenge when presenting images of maquettes, toiles, sketches and other developmental work is to retain the sense of spontaneity and the organic way in which ideas were developed, without compromising the quality of presentation or overall aesthetic of the project.

Approaches to the presentation of developmental work vary, so if sketchbook work is integral to the way you explore ideas, it is good to show this: perhaps simply by taking a sketchbook with you to the interview, perhaps by bringing an edited version or even scanning work and re-presenting it as 'development boards'. The layout, presentation,

Process and realization...

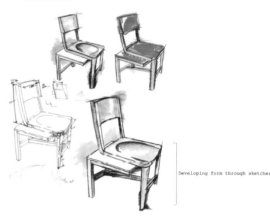

1:5 scale models

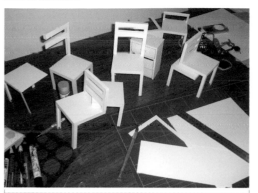

Developing form through sketches

## Illustrations 15, 16

*Mark McKay (illustration 15, left) and Marina South (illustration 16, below) both use examples of developmental work as an integral component of their presentation, thus demonstrating evidence of their respective creative approaches and the thought processes behind finished projects.*

Design Development.

Effortless drape creates a soft silhouette. Something considered and purposeful looks so simplistic and understated.

16

structure and order of a portfolio should help to illustrate the thought processes and key ideas behind individual projects and the broader body of work. Incorporating developmental work is often an important way of doing this.

## OTHER PORTFOLIOS

The word portfolio literally refers to a case or folder for carrying sheets of work. However, portfolios are increasingly taking any number of diverse forms, including boxes, flipbooks, USB sticks and, of course, online portfolios. Adopting more innovative approaches to presenting your portfolio allows you to design a format tailored to your specific presentational and promotional needs that is linked to your creative practice. Of course, it makes no sense to choose an unusual format for its own sake, but if, for example, you are a skilled bookbinder and this process is a key part of your practice, it makes sense to present your portfolio as a handmade book. Similarly, if your work is mainly digital or involves moving images, it makes sense to have an online presence. And there is of course no reason why you shouldn't have different formats of portfolio to be used in different contexts.

## Emma Southgate, service designer at Participle, a public service design agency

Emma Southgate's background is in product and furniture design. Her portfolio takes the form of an archive box containing booklets featuring individual projects, which have been designed to resemble corporate documents. Presenting her portfolio to the Design Directions award panel, Emma took on the role of the representative of a fictitious company in order to explain her concept. She subsequently won the award.

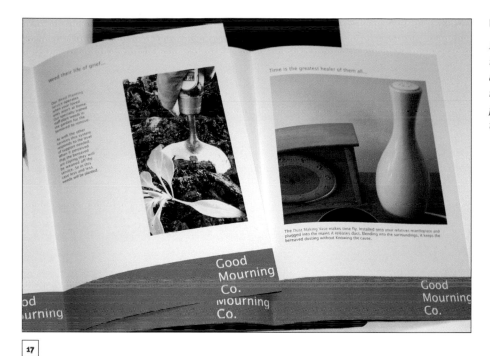

**Illustration 17**

*Emma Southgate adopts an innovative and integrated approach to form, in which narrative and performance become part of the experience of viewing the portfolio.*

17

'My portfolio is a box, it's a box for photographs, an archive box. These are my projects, which come as little booklets. When I was interviewed for the Design Directions award I went dressed up as a salesperson from Good Mourning Co. with a briefcase, and in my briefcase I had these products and white gloves. I had a Good Mourning Co. ID badge on. I went and I acted out that role and I sold it, I was doing a sales pitch to them.'

What is interesting about Emma's approach to her portfolio is the way in which she used presentation and even performance as an integral part of her work. While Emma's approach was of course very particular to her practice, the idea of using the form and presentation of your portfolio to articulate the identity and key concerns of your work is of much more general relevance.

As we have discussed, there is a sense in which a portfolio is as much a concept as an object. At the beginning of an artist's or designer's career, promoting his or her practice through a variety of means is an absolute necessity; indeed, without doing so, those first starting out might not get the chance to present their work in person. Therefore packages, CVs,

PDFs and other promotional materials such as postcards and badges can be considered as part of a broader promotional strategy – as mini or auxiliary portfolios, if you like. Whether sent through the post or by email, these materials act as a concise snapshot of your work and as such need to be treated with thought and consideration.

In contemporary art, design and illustration, it is common to send unsolicited promotional materials in the hope of getting someone's attention. Doing this well means investing considerable time and resources to produce a leaflet, booklet, series of postcards or other package that in a highly edited, concise way communicates the essence of your work.

Quirky and eye-catching packages are perhaps more appropriate for freelancers and recent graduates than for more experienced professionals seeking a permanent position in a company. However, for these two groups in particular, sending packages through the post has a significant advantage over using email. Without a contact or at least the details of a relevant individual, emails run the risk of being ignored or deleted by a busy HR department.

For more experienced practitioners, a PDF comprising a selection of pieces from your portfolio and a CV may be considered a more professional initial approach. PDFs should be presented as beautifully as your portfolio, although they may well represent quite a heavily edited version. They should also be fairly light, so as not to clog up the computer network or email inbox.

In the case of both physical and digital promotional materials, it pays dividends to word an accompanying letter carefully. An employer who receives an unaccompanied application is likely to completely ignore the material, files, links and attachments sent because the applicant immediately appears unprofessional and, worse, downright rude. The tone of a covering letter or email should be enthusiastic but not too gushy, and it needs to be focused on the company or organisation you are contacting. Explain what attracts you to that specific organisation and mention previous work, exhibitions, projects, collections or campaigns they have undertaken, describing why you admire or relate to them. Equally importantly, state what you have to contribute: what skills and experience do you have, and how can they be spun and focused to sound

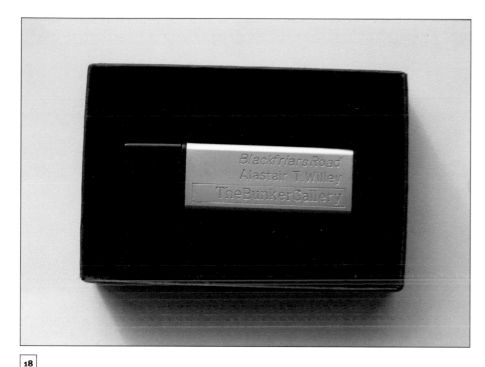

**Illustration 18**

*By engraving and personalising a USB stick and presenting it in a velvet-lined box, Alastair T. Willey subverts our expectations, conjuring a mundane office item into a precious object. At the same time, the USB stick is an effective and portable means of transporting and presenting pieces of work. Alastair originally used the form in the context of an exhibition, in order to allow viewers to see additional pieces of work not on display.*

18

particularly relevant to the application in question? Finally, if you are responding to an advertisement or a tip-off about a vacancy, concentrate on the required qualities and skills that have been referred to and how you can respond to the needs the organisation has identified. And remember, letters addressed to a specific individual are much more likely to be successful, so get hold of a name if you can, by hook or by crook.

*Illustrations 19 and 20 are examples of work by Agnese Bicocchi. Illustration 21 shows postcards, badges and a customised envelope by illustrator Agnese, who considers her promotional materials down to the very last detail. Touches such as a stencilled envelope and the carefully chosen print of the paper bag demonstrate a commitment to excellent presentation; in turn, this reflects Agnese's practice as an illustrator and, crucially, leaves you intrigued and anxious to see more.*

## Agnese Bicocchi, illustrator

Agnese Bicocchi is an illustrator with extensive experience in editorial illustration as well as a dynamic personal practice (agnesbic.com). She has worked for publications and brands including the *Guardian*, *La Repubblica*, Unilever, *Time Out*, Stereohype and *The Big Issue*.

In addition to commissions for editorial work, Agnese produces work independently to exhibit. She also makes badges, postcards, booklets and leaflets; these act both as an extension of her creative practice, embodying her exquisite, hand-drawn, nostalgic aesthetic, but also potentially function as promotional materials, as she explains:

'When I went to see Time Out magazine, I had some fanzine work and drawings that I'd been producing for myself. I thought, maybe this doesn't look very professional, but as they knew, I had only just graduated. I made them a promotional pack and left them lots of drawings of people, which I'd

19

**Illustration 22**

*An exhibition postcard and an
artist's book by Ralph Dorey.*

been working on. From this experience I understood that it is very important
to be confident with what you show in your portfolio, as it's very likely that
you will be asked to produce something similar. For instance, because I'd been
making drawings concentrating on hair, my first brief for Time Out was a
hairdressing brief. In fact it had just been an exercise — I could have been
drawing glasses or anything — but it got me my first professional brief, which
was great.'

Getting an interview with a widely read, popular magazine like *Time Out*
is a real coup for a graduate illustrator. By leaving a promotional package
and examples of her illustrations, Agnese not only demonstrated keenness
and a body of appropriate work, her innovative and creative approach
also ensured that images were at hand at an opportune moment. Leaving
an *aide-mémoire* at an interview helps the interviewer keep you (and your
work) in mind, meaning that if an appropriate brief comes up, they are
much more likely to contact you.

Artists or designers who are launching a career as independent, self-
employed practitioners will also produce promotional materials, for
example to advertise an exhibition, to distribute to the press or to promote
their work to galleries and boutiques. At the same time, practitioners may
find a booklet or postcard an interesting and relevant form in its own
right. Creating materials to promote and further explain your practice
could be a creative as well as a useful exercise.

## Ralph Dorey, artist/sculptor

'Even choices such as whether to email work or send it by post can be significant. If
it is imperative to send an application as quickly as possible, obviously email has the
edge, but posting a hard copy can give you a lot more control. The paper you choose to
print on, scale and size, binding images to form booklets can all affect how your work is
received and interpreted. [Ralph has produced booklets designed as a presentational tool to
be sent to galleries or given to prospective exhibitors after a meeting.]

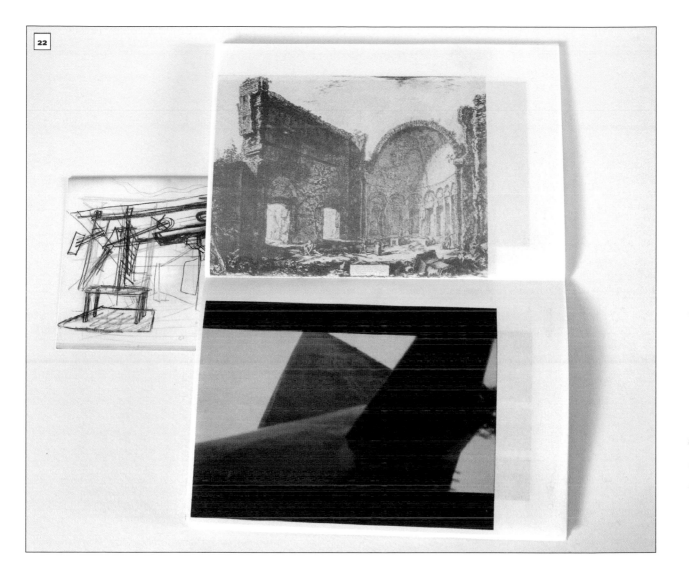

As a sculptor, I often come across the problem of trying to present large, three-dimensional, tactile objects as small two-dimensional photographs. I avoid the temptation of attempting to recreate the experience of looking at a sculptural piece by producing a book of my drawings and images I have found or "stolen" — stills from films, photographs etc. At the same time, the booklet allows me to explore and explain ideas which are important to my practice.'

Perhaps the most fundamental promotional tool is the CV, but it is rarely paid sufficient attention – particularly in art schools. A well-presented curriculum vitae is an essential component of your auxiliary portfolio. Across the design disciplines, CVs are expected to be visually interesting documents as well as being clear and concise sources of biographical information. Depending on your discipline, sensibility and taste, your CV may include images of your work or simple abstract graphic devices, or perhaps might give you the opportunity to unleash your inner Bauhaus typographer. In any case, even if your presentation is minimal and understated, the CV of an artist or designer should avoid looking like the generic CV of an office worker. Conversely, self-consciously wacky CVs only communicate that you are self-consciously wacky, and so are best avoided. There is a fine line between a CV that is personal and one that is silly, so it is important to consider if your presentational devices make the information contained in the document easier to access or more difficult, or if images actually contain additional useful information. Another point to consider is the relevance of the biographical details that you include in your CV. Potential clients and employers will be most interested in information that is directly pertinent to your application – for example student design or art competitions which you have entered, and of course any internships or professional positions which you have undertaken in your field. More personal details should only be included if they directly support your application. For example, if you are applying for a design position in a sportswear company it may well be appropriate to mention your passion for body-boarding. Equally, it may be appropriate to include a short, well-written paragraph focused on your creative influences – whether this is street culture or baroque art – towards the end of your CV. However, no one is going to be interested in whether you were head boy at sixth form, or whether you have a Duke of Edinburgh award, so it is advisable to leave these kinds of references out.

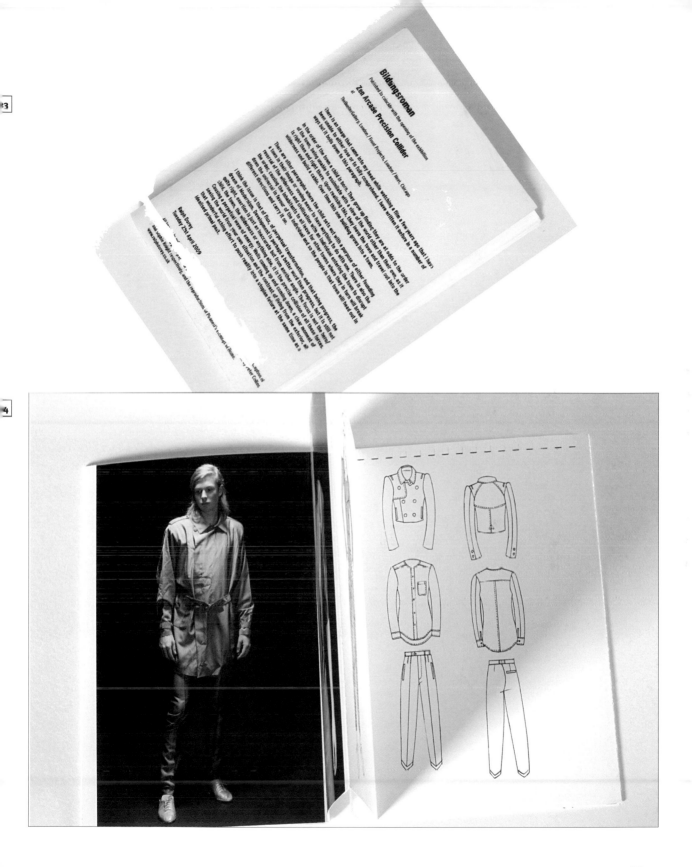

**Illustrations 25, 26**

*Chloe Sharpe's CV is an excellent example of a considered and well-judged document.*

# Chloe Sharpe

## Personal Details

Name: Miss Chloe J Sharpe
Address:

D.O.B.
Email:
Mobile:

## Key Skills / Interests

AutoCAD 2006
Autodesk 3D Studio Viz
Adobe Photoshop
Adobe Acrobat
Microsoft Office XP
(Word, Excel, Outlook, PowerPoint)
I.T and internet understanding
Model making
Sketching/Fine art

Spatial Psychology
Ideas Communicati
Problem Solving
Team Player
Self Motivated
Time management
Organisational skill:
Installation art
Multi-media techno

## Employment

| | | | |
|---|---|---|---|
| 2005<br>Jun-Sep | **Studio BAAD Architects**<br>Design development, computer rendered visuals, sketches, AutoCAD plans,<br>sections, elevations, detailing, lighting plans, fire/safety plans, onsite visits | Hebden Bridge,<br>Calderdale,<br>Yorkshire |
| | - Mongolian TV Stage Set   (News, kids set, forum, breakfast show)<br>- BBC Manchester        (Office from office)<br>- Mine, Leeds University   (Bar and music venue) | |
| 2004 | **Next Retail Ltd**<br>Sales assistant, runner, warehouse, restocking | Next, central<br>Leeds, Yorks |
| 2001 | **Solar Co-Op**<br>Shop assistant, shelf restocking | Framlingham,<br>Suffolk |
| 2000 | **BT Laboratories**<br>Secretarial office work, logo designs | BT, Ipswich |

## Education

| | | |
|---|---|---|
| 2003-06 | **BA (Hons) Interior Architecture & Design**<br>Leeds Metropolitan University. Explore, respond and manipulate interior built<br>space. Level of detailing and structural knowledge. Experimental, art-based<br>approach, critical/contextual studies in Design, Architectural History, Theory. | **First Class<br>Honours** |
| 2002-03 | **BTEC Diploma – Foundation Course in Art and Design**<br>Norwich School of Art and Design<br>Drawing and critical studies, developing observational, analytical, research<br>and written skills, focussing on 3D experimental design. | **Distinction** |
| 2000-02 | **A Levels**   (Northgate High School – Ipswich)<br>Art, Information Technology, History, General Studies | **A, A, B, A** |
| 1995-00 | **GCSE's**   (Debenham High School – Suffolk)<br>Science (Double), History, Maths, English, English Lit.<br>Religious Education, Textiles, German, Art | **A\*A\*, A, A, A, A\*<br>A\*, A\*, A\*, A\*** |

## Awards

| | |
|---|---|
| 2006 | **Bob Peacock Prize for Most Creative Student**<br>Leeds Metropolitan University |
| 2005 | **CSD Student Medals - Commendation for Exhibition Design**<br>Chartered Society of Designers, student membership awarded |
| 2003 | **Norwich School of Art and Design -** Commendation<br>Tutor Awards |

*Chloe Sharpe pg. 1 of 2*

# Chloe Sharpe, interior designer

'In terms of my graduate CV, it was carefully considered and similar in style to my portfolio. I think with any design CV, it's really important to include images, but it also has to be legible and concise. I think it is important to strike the right balance between something that looks creative and personal but is also

# Sample Projects

**'Mine' – Leeds University Union Bar    (Studio BAAD team)**
*Brief:* Leeds University proposed the refurbishment of a derelict bar to offer all day refreshment and 450 capacity music venue and night club. Completed 2005.
*Studio BAAD Solution:* The theme *'enjoyment of outdoor spaces'* influenced an informal eating and music venue with a sunken tube dance floor and stage, viewing bridge, 'letter-box' booth seating, shaped metal benches and dramatic lighting design.
*Learnt/Role:* AutoCAD plans and sections, furniture selection, onsite surveys, lighting and safety plans, contractor discussions, time management, budgeting

**Creativity Gateway – Unleashing corporate minds – Conversion of Salem Chapel**
*Brief:* To design a stimulating hired venue inducing innovative ideas for product driven industries and provide the skills to solve future problems. Using the existing building to add to the sprit of the space and as a catalyst for regeneration of the area.
*Solution:* The stages of the ideas process are followed from problem identification, to production, to ideas exchange. Multi-sensory environments manipulate the thought process of role-playing activities based on the company problem or product.
*Learn/Improved:* Sectional perspectives, psychology of space, project management

**Chartered Society of Designers Competition – Patterns in Nature – Exhibition**
*Brief:* Promote park regeneration and nature conservation with links to local schools targeting key stage two children.
*Solution:* Interactive sculptural digital exploration. Emphasise life flowing through the building into the park through moving images of plants and animals living within screens. Encourage young detectives to discover the park for themselves.
*Learnt/Improved:* Photoshop skills, conceptual sketches, multi-media technologies
                                     *Commendation awarded by CSD Student Medals

**Renovation project – Kirkstall Valley Park Visitors centre 'Connections'**
*Brief:* Develop a scheme for a multi-purpose-venue for the promotion of KVP. Visitor exhibition centre and offices within a 1908 tram station on the outskirts of the park.
*Solution:* Connecting the park, developers and city as one. Improving public relations by integrating developers' offices with public space. The flexible environment is also sustainable for future development and adaptable for internal and external exhibitions.
*Learnt/Improved:* Graphic communication and layout, Computer renders, materials and details, requirements and restraints with a public building, building regs.

**Atelier and Staircase – Librarian's Dwelling**
*Brief:* Dividing the volume of the space, staircase design and construction to produce Atelier suitable for specific chosen profession.
*Solution:* Multi-purpose staircase design acting as the 'central column of knowledge' for shelving, seating and access. Plains of timber flow beyond the central staircase to become work surfaces, benches, steps and floors.
*Learnt/Improved:* Client requirements, spatial limitations, building regs for private dwellings, model making, communication of construction and detailing.

**RSA Competition: 24 hr living: Public Information Point 'Urban Crossroads'**
*Brief:* Proposed by Royal Society of the Arts to design a response to the 24hr living concept focussing on encouraging social integration within the city
*Solution:* An 'urban crossroads' maximising the overlap of diverse living patterns. It is an interactive transitional space which acts as a generator of ideas, information and interaction between a diversity of people to allow for a more informed decision making process. Can be used for general information or hired to promote local events.
*Learn/Improved:* Photography lighting, public amenities research, conceptual models

professional. The project images on my CV were chosen to demonstrate a variety of presentation skills and a variety of project types. For example, I included both conceptual and realised projects, hand-sketching, computer-generated images, model-making and photography.'

**Illustration 27**

*Using collage and Photoshop techniques, Lili Golmohammadi has created a visually refreshing and energetic CV. At the same time the document remains easy to read, and is sensibly and logically arranged.*

# DIGITAL PORTFOLIOS

In the past few years, websites and online portfolios have moved from being a novelty to the norm, most notably in graphic design, illustration and contemporary art. Online portfolios are particularly useful for practitioners who work on a freelance basis: illustrators, for example, will often initially present their work to an editor or art director via a website or PDF. Websites tend to be much more appropriate for artists and designers who work independently, as they are in effect constantly looking for new clients and collaborators, than for those who are salaried employees of a single organisation.

27

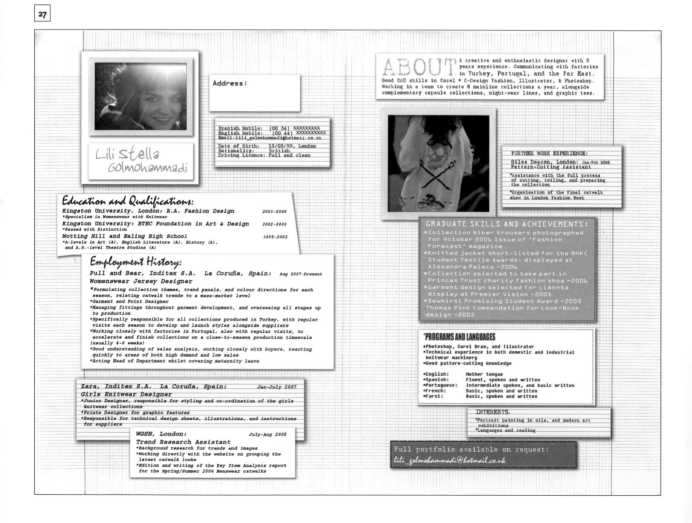

# Paul Vincett, 3D illustrator

Paul Vincett sells a successful range of handmade toys and puppets through his website, stitchesandglue.com.

'My presence online has been the key to everything, it has allowed my work to be seen by people across the globe. Most of my commissions actually come from America, which without the internet would be incredibly difficult. Advertising and getting the word out on your work is always the main battle. Self-promotion is something that needs to happen all the time, to take advantage of everything and get a presence in the places your audience goes to. With blogs becoming

**Illustrations 28, 29, 30, 31**

*Illustrations 28 (above) and 29 (overleaf) show pages from stitchesandglue.com, an example of the website as the nexus of a creative online promotional strategy. Illustrations 30 and 31 (overleaf) are examples of original model-making thoughtfully presented by Paul Vincett.*

more popular, from magazines to sites dedicated to everything from the handmade to designer toys, the chance to reach like-minded people has greatly increased. I frequently get in touch with blogs that share my interests with updates of my work — things that are about to go on sale — to get reviews, and it's surprising how many contacts and commissions I get due to this exposure, because I am reaching my audience more directly.'

It is very tempting to imagine that websites are an easy technological solution to all your promotional problems. But as Paul explains, it is not sufficient simply to design your online portfolio, go live and expect clients and employers to flock to you. Instead, a website needs to act as the central component in a broader promotional strategy. Professional practitioners will often have multiple platforms online: in Paul's case, blogs are an important way of reaching his target audience. As ever, appropriate promotional strategies will be reliant upon the specifics of individual practice, but useful platforms include sites such as childrensillustrators.com and illustrationmundo.com in illustration, or axisweb.org and Saatchi Online for fine art. Clearly, being featured in magazines and journals, whether internet-based or not, is also likely to increase the number of hits on your site. For designer-makers, the websites of organisations such as Craft Central (craftcentral.org.uk) and the Crafts Council (craftscouncil.org. uk) are very useful platforms in their own right, as well as helping to direct potential clients to your own website.

29

30

31

# Zack McLaughlin, children's book illustrator

'Although I have a portfolio folder [containing original drawings, full-size images and facsimiles of books], the primary point of contact for most of my clients is my website, so it is definitely my most important portfolio. However, on meeting clients, I may present my folder, as it displays some qualities which are difficult to appreciate on the screen — scale, detail, and the texture and nuance of original hand-drawn artwork.'

**Illustrations 32, 33, 34**

*These images are drawn from the website of Zack McLaughlin. Zack displays his meticulously detailed children's illustrations in a virtual environment which maintains a strong sense of his aesthetic sensibility by using hand-drawn, uneven and textured type and backgrounds.*

# Diana Kaur, independent curator and editor, Stockholm

'I think that a website can be an important tool. I've seen many very bad artists' websites and I've seen some really nice ones too. Bad websites, first of all, are not user friendly: they have badly written texts and are poorly edited; the artist wants to show everything and everything is never good, you really have to edit quite strictly. In contrast, a website that I really like, which I think is really quirky, is Helen Mirra's website, hmirra.net. It's very simple, easy to navigate, quite minimalist and thoughtfully presented, and it's got her signature written all over it. There are very few texts — she's written most of them herself and they are related to her work in a strict conceptual way — and a few well-chosen and appropriate images. Similarly, you can choose to access her work in different ways, either chronologically or geographically. It just suits her practice so well, and it's a great tool for anyone who has seen one of her works to get more acquainted with her as an artist. But it isn't too much. What a good website does is to whet your appetite but leave you wanting more. So there should be sparse but relevant documentation.'

Depending on their technical capabilities, some artists and designers may be able to design their own websites. Dreamweaver is currently the dominant program used in web design. It represents a more visual approach to programming and is favoured over other website-building applications because it writes code for you, requiring no sophisticated understanding of HTML, the mark-up language in which most websites are written.

Dreamweaver is often used in combination with Photoshop to design the visual elements of the page, but templates can be created in other programs, such as InDesign. Flash is also widely used in websites to create interactive features and for moving images and video. The alternatives for those unable to use such programs are to use a template sourced from the internet – yola (www.yola.com) is one of the most widely used – to download images and text on to a blog, or even to use social networking sites if an immediate online presence is needed.

It is necessary to maintain a balance between the time, effort and/or money required to build a website from scratch and the potential loss of

## Illustrations 35, 36

*Irrespective of the form or forms your portfolio takes, what is most important is that it is relevant to you. Notice the striking difference of aesthetic in the two sets of images: they are both drawn from websites that belong to illustrators (Agnese Bicocchi, illustration 35 and Zack McLaughlin, illustration 36), but their semantics and approach to presentation are not at all similar.*

35

36

control over the presentation, layout and interactivity of the resultant site. If you are enlisting a friend to design your website, it is essential to be very explicit about how you envisage the site working, as well as the feel and aesthetic you want to create. It can be advisable either to design or mock up web pages in Photoshop or InDesign to maintain as much control over the process as possible. One benefit of enlisting the help of someone knowledgeable in programming is avoiding the large websites typical of Dreamweaver. Refining unnecessarily complex codes which tend to be generated when using the programme can help the resultant website load more quickly and avoid potential problems for users.

Presenting work online has the advantage of immediacy and accessibility, but a website needs to be put together with as much thought and care as any other portfolio, if not more, as well as being kept up-to-date. However, while it can bring benefits, the accessibility of online portfolios can also encourage the risk of plagiarism, particularly in areas like fashion, where intellectual property is notoriously difficult to prove. More generally, practitioners should be aware of the norms and expectations (conventions) of their particular field. For example, fine art online portfolios tend to mirror other contemporary art spaces by being stark and minimal. Most importantly, as with any portfolio or promotional tool, a website should be personal and should fulfil your particular needs as a practitioner. Funky animated graphics are an irrelevance if a website is so difficult to navigate it is impossible to find the work.

## MORE ON PDFS

A multi-page PDF document has become the norm for sending an edited selection of images to a potential employer by email. Unlike a website, a multi-page PDF can be quickly and easily generated to match the profile of a particular organisation, making it a very effective approach to creating a digital mini-portfolio for a specific application. Images generated in or scanned into Photoshop, InDesign, Illustrator or even Microsoft Word can be saved individually as single-page PDFs and then ordered and combined, for example using Preview on a Mac or any other PDF-editing program.

Sending a single concise and focused PDF file looks more professional than attaching individual jpegs. This is especially true for a speculative application or approach, because it makes your work much more convenient to look through. Practitioners who have a personal website or whose work is featured elsewhere on the web should never simply send a covering email with a link to their site: it is important to show that you have taken the time to consider the identity and requirements of the organisation you are approaching, and have selected work you think is particularly relevant to show to them. If they like what they see, then they are likely to want to find out more by visiting your site.

## Charis Theobald, graphic designer

Co-founder of graphic design practice Studio Brink, Charis Theobald has extensive experience across branding, print and web design, and has worked with clients from such diverse areas as film and television, education, health and beauty, and fashion.

'A short PDF portfolio, which you might send speculatively or as part of a job application either to a design studio or to a potential client, would normally consist of no more than ten pages. People are busy — it's important to create a positive first impression, and leave them wanting to know more! It's a highly

edited form and an introduction to you as a designer. Within those few pages, you have to give an idea both of your previous experience and of the sort of work you would like to do in the future.

'I would recommend having a first page with your logo, name and contact details as a cover or introduction to the portfolio. It encourages the viewer to remember your name for starters, looks professional, and going straight to a page of work when you open up a PDF can be a little abrupt. As this is a highly visual discipline, the introductory page and portfolio page layouts need to be well designed. I would advise keeping it fairly neutral and classic in terms of design, rather than being very trendy or very corporate, as you may well be approaching a range of clients from different backgrounds. Most importantly, your logo and layouts need to support the variety of work you have produced, not fight it for attention.'

As ever, the key to successful presentation lies in considering your needs as a practitioner along with the needs of your audience. Before embarking upon the design process, it is important to ask yourself who the audience of this portfolio is, how the portfolio is going to be accessed and what information you need to communicate. Having concrete promotional aims you want to achieve through the creation of your portfolio is much more likely to result in a successful online presence than rushing out a website in the anxiety of being left behind.

## Summing up

Presentation is one of the most complex problems to resolve when putting together a portfolio. There are various competing demands in terms of creating a body of work that reads coherently; can be edited and updated easily; is original, professional and, importantly, is visually and aesthetically effective. Nevertheless, as we have discussed in this chapter, by considering your needs as a practitioner and the needs of your audience it is possible to design a portfolio, or portfolios, that will effectively address these concerns. It may be helpful to consider the following points as a sort of presentation checklist:

*Form*   The form and size of portfolio you choose should relate to your needs as a practitioner: A4 black portfolios are popular because they are neutral and portable, but they should not be the assumed option. Boxes, bound books, Perspex folders, even flipbooks can be more suitable to your practice, and they are certainly more original. Even seemingly superficial decisions, such as choosing a khaki or burgundy portfolio if appropriate, or one that isn't a standard A-size, can make your folder a bit more special. Even if a black A4 or A3 portfolio is the most sensible option, remember that they are not all the same: choose carefully and thoughtfully.

*Order and editing*   Order is one of the most basic presentational devices but it is surprisingly effective and important. Consider the questions and responses that particular pieces of work are likely to elicit, and edit and order your portfolio to tell a story and to lead an interviewer on a specific journey through your work. Always start your portfolio with a knock-out project. If you look at a piece of work and find yourself trying to excuse it, take it out or rework it. And always make sure that the work you are taking to a specific interview is appropriate – you can always take a separate folder of more risky or personal work and show it if the interview is going well.

*Presentational devices*   Use graphic devices, titles and text where appropriate to support, clarify and contextualise your work. Presentational

devices can be as complex or simple as you like, but they must be relevant to your work. Remember, no one is going to read reams and reams of writing, so limit text to short explanations or key phrases.

*Aesthetics*    Your portfolio needs to demonstrate a developed and coherent sense of visual aesthetics. This means considering how pages are composed and laid out, as well as colour relationships and balance within an individual page and across a spread. Equally, it is important to consider the semantics – the meanings and associations – of particular graphic devices, colour relationships and typefaces; these can be used to frame work as being modern or nostalgic, quirky or corporate. If this sort of presentation isn't your strongest suit, and even if it is, consider referring to an appropriate source such as a Victorian picture book, a book of Bauhaus graphic design, a vintage magazine or similar, and copy or draw inspiration from their treatment of presentational problems.

*Multiple portfolios*    If you are applying for a number of quite different positions, or if your practice runs across a variety of distinct disciplines, it is probably a good idea to have more than one portfolio, which may take a variety of forms. More generally, it pays dividends to edit your portfolio for each interview or meeting you have, even if it is only a simple case of re-ordering the folio or including an extra project.

*Other portfolios*    You may have a beautiful portfolio sitting at home, but it's no good to anyone if it is never seen. Sending speculative applications and publicising your work using packages, booklets, postcards, PDFs and other materials are useful activities for aspiring artists and designers. This is especially true for freelancers, independent practitioners and recent graduates, who are in effect constantly looking for new work. These 'mini portfolios' provide a snapshot of your work and will not be nearly as extensive as your portfolio proper; therefore, they need to show a carefully chosen selection of projects that are representative of your practice and focused on the recipient. It is also important to consider how you present your CV and write covering letters. Thinking about all the materials that sit outside your portfolio, try to present a coherent and

considered approach to self-promotion. And most importantly, always take care to send materials with a covering letter or email focused on the specific organisation you are contacting.

*Digital portfolios* Websites are increasingly important for freelance and independent practitioners, as well as in fields such as contemporary art, graphic design and illustration. Online portfolios can certainly be very useful tools, but they are not a panacea: as with any portfolio, they need to be well designed, carefully edited and easy to use. Common website mistakes include confusing menus, pages that are slow to load and formats that don't fit smaller screens. However, well-designed and well-publicised websites can attract attention to your work far more efficiently than a conventional paper-based portfolio. Those who use their websites most effectively are often practitioners who employ a broader online promotional strategy encompassing specialist websites, blogs and even social networking sites. While websites are a great tool for attracting attention, multiple-page PDFs are probably better for making a specific application or approach. This is because they can be easily edited to suit a specific organisation and thus appear more personal than a web link. As ever, always send PDFs with a personal covering email.

# PORTFOLIOS FOR EDUCATION

While the majority of this book is concerned with portfolios in a professional context, this section is focused exclusively on portfolios in art and design education. Entry to art and design courses at all levels, from foundation course to postgraduate degree, is primarily awarded based on the submission of a portfolio (and/or interview with portfolio). Surprisingly, despite this centrality of the portfolio to a successful application, there is very little useful or concrete advice available to applicants. The purpose of this chapter is to provide a framework of key ideas around which to structure a portfolio for application, reflecting your creativity, skill, knowledge and individual sensibility.

Many of the themes and ideas discussed elsewhere in this book remain relevant, and students should certainly feel free to draw on examples and advice from other chapters. Nevertheless, there are real and important differences between the expectations and conventions of the portfolio in education and in professional practice. Typically, employers are looking for a candidate with quite a specific skill set, one who is able to produce work suited to the organisation in question, and who has an understanding of the realities of the marketplace. In contrast, educators are rarely looking for fully formed practitioners, and are not necessarily interested in students who are able to work in a commercial idiom. Rather, art and design courses at all levels are keen to recruit students who demonstrate originality, flair, and a capacity to learn and evolve. Curiosity and an engagement with visual culture and the arts are also valued. And it is these qualities, along with an appropriate level of technical ability and aesthetic sense, which need to be communicated effectively through the individual projects and pieces in your portfolio.

# FLAIR

## Andrew Foster, illustrator and senior lecturer, MA Illustration, Central Saint Martins

*'Flair and individuality are the key things that I'm looking for in an applicant's portfolio. You are hoping to be wowed by an applicant who has a really strong and individual creative voice, which, ideally, is backed up by wonderful craft skills.'*

Lecturers interviewing prospective students at popular foundation or degrees courses go through hundreds of portfolios. During this process, they are looking for students with a sufficient level of technical and conceptual skill to be suitable for the course. However, as Andrew Foster suggests, what really excites interviewers is work that demonstrates flair, creativity and a capacity for invention. Energy, fresh ideas and a distinctive individual voice are qualities that should distinguish your portfolio and will help you to secure a place. With numbers of applicants increasing, many popular courses now pre-vet portfolios, granting interviews only to students with the strongest folders. As you may not be present when your work is initially assessed, it is vital that your portfolio communicates effectively, without the need for verbal justification. Going through folders takes up a vast amount of staff time and interviewers are liable to flip through your work swiftly. It is essential therefore to have at least one project in your portfolio with real flair, that is, a piece with sufficient visual and conceptual impact to make people take a second look.

## John Bowstead, artist and lecturer with over thirty years' experience

*'Perhaps the best example of "flair" I have seen from a student was also the most low-key and I guess one of the wittiest. The student group had been on a trip to a museum of design, and as usual they were asked to react to their experience by producing an object or image that reflected their response to the museum. The*

# INSIDE DECONSTRUCT

## JUST A BLAZER?

### 3. EMBRACE THE HOOD
TRANSFORMING A NORMAL LOOKING BLAZER JACKET INTO SOMETHING YOU WOULDNT
WEAR TO A BOARD MEETING
PHOTOGRAPHY BY PARMINDER MATHARU, STYLING BY MANVEER SAGOO

### 9. FRONT TO BACK
TURN IT AROUND AND UPSIDE DOWN, WHAT DO YOU GET?
PHOTOGRAPHY BY PARMINDER MATHARU, STYLING BY MANVEER SAGOO

### 14. BLAZER REBORN
THE BLAZER THAT WAS REBORN TO MAKE A DIFFERENCE
PHOTOGRAPHY BY PARMINDER MATHARU, STYLING BY MANVEER SAGOO

### 18. BRIGHT AS SUMMER
WHAT MAKES MANISH ARORA SO UNIQUE,
JUDGE HIS SPRING/SUMMER 09 COLLECTION FOR YOURSELF

### 20. HIDDEN GEMS
REVIEWING BOUTIQUES ON CARNABY STREET
CLASSIC LEATHERY DOORS OR TRULY UNIQUE BEYOND THE VALLEY
PHOTOGRAPHY BY MANVEER SAGOO

**Illustrations 1, 2, 3,**

*Foundation project by fashion student Manveer Sagoo, presented as a fictitious magazine. In this project, Manveer has taken an iconic and universally recognisable garment – the suit jacket – and with humour and panache presented it in new and unexpected ways. At a very early stage of specialist art and design education, Manveer has produced high-quality, interesting and original work. The level of presentation, with its careful consideration of type and layout, elevates a quirky idea to a well-resolved and robust project.*

museum itself was fairly unexciting and the journey there and back a long one. A couple of days later the students had a crit on the work they had produced, some of which was quite inventive, possibly more so than much of the exhibition they had seen. The last piece of work in the crit took the form of a video. There was no title. The audience watched as a large piece of board came into focus. The board was then covered in white paint. After this nothing happened for several minutes. The audience of staff and students became somewhat restive, but still nothing happened. The painted board remained as it was. Clearly, people were getting fed up and ready to leave. All of a sudden, one of the staff said, "You know what we're doing. We're just watching the paint dry." "Exactly," said the video maker. "The other day was just about as interesting as watching paint dry."'

As John Bowstead suggests, flair is often about having an unusual and inventive take on a given brief. Similarly, the most interesting ideas often occur when practitioners come at a problem from a completely unexpected and idiosyncratic angle. Flair may manifest itself in a variety

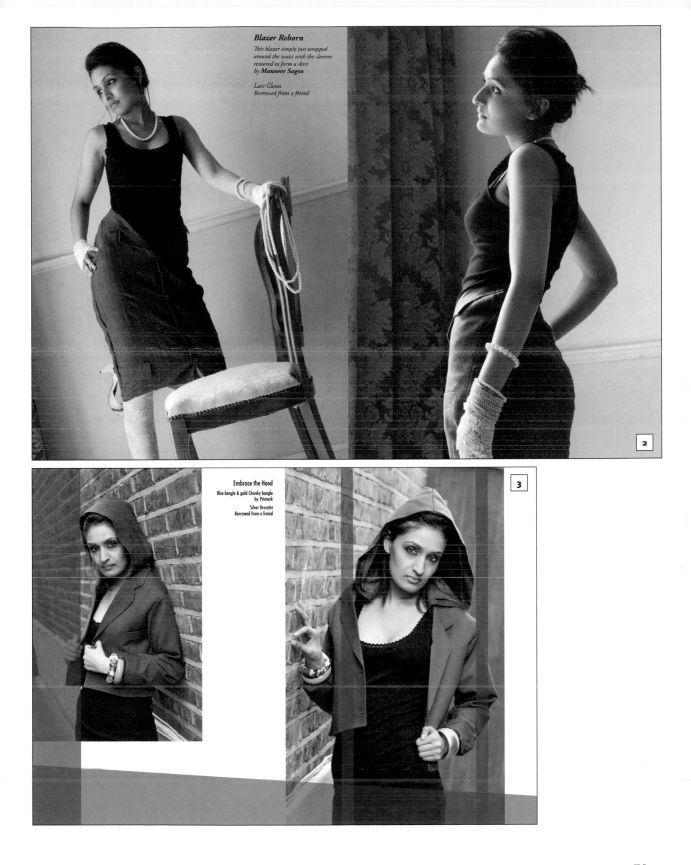

**Blazer Reborn**
*This blazer simply just wrapped around the waist with the sleeeves removed to form a skirt*
**by Manveer Sagoo**

*Lace Gloves*
*Borrowed from a friend*

2

3

**Embrace the Hood**
Blue bangle & gold Chunky bangle
by Primark
Silver Bracelet
Borrowed from a freind

of ways depending on your sensibility as an artist or designer, as well as on your level of study and specialist subject.

Artists and designers often come up with striking work by radically re-imagining the world. Taking a mundane object and turning it into something totally original and bizarre is a trick artists such as Man Ray and Picasso used to great effect. However, even practitioners at the very beginning of their art and design education can come up with interesting and engaging pieces of work by looking at the world with fresh eyes and by transforming the everyday into something new and exciting.

Another way of demonstrating flair and invention is to think about portraying experiences that are rarely represented in conventional image making. In the pieces opposite, taken from an A-level portfolio, the artist's intention is to evoke the frenetic movement, noise and buzz of city life. Instead of a flat canvas, the painting exists on multiple plains that rotate around a central fulcrum. In this way the composition is dynamic, constantly changing and evolving – just like the city. Brightly coloured abstract and semi-figurative elements suggest advertising hoardings, architecture and human forms. The artist's ability to think beyond conventional approaches to composition makes this an unusual and ambitious piece for an A-level student, demonstrating conceptual creativity as well as panache and confidence in execution.

In many ways, demonstrating flair is about having the confidence to make work that communicates your personality. In the images overleaf (6 and 7) from a work entitled *Neutrino*, artist Andy Charalambous is engaging with some big ideas around art, science and technology. His use of light, lasers and moving mobile-like structures in an immersive environment is also impressive, especially as this piece was produced in a degree-level context. However, what makes this work most interesting is that it is a reflection of Andy's idiosyncratic concerns as an artist: it is indicative of the way he thinks through and explores ideas in his work.

So if you are naturally drawn to making work that is small in scale, perhaps you need to exaggerate that tendency by making minutely detailed works that have to be viewed using a magnifying glass, for example. Equally, if you find that your paintings are more concerned with process than the finished image, perhaps experiment with filming

**Illustrations 4, 5**

*Images from the A-level portfolio of Theo McCauley Bowstead. This student's unusual approach to image making and composition is executed with a flair for colour, pattern and abstract qualities. The strong visual impact of Theo's project demonstrates a distinctive individual sensibility and an ability to think creatively.*

the production of the painting and present this video as a series of stills in your portfolio. After going through the twentieth portfolio of the day, there is nothing more pleasing for an interviewer than to come across work that has genuine energy, personality and guts, and really communicates a strong sense of the person who made it.

**Illustrations 6, 7**

*Sketchbook development and photographic documentation of* Neutrino *light installation by Andy Charalambous.*

## CULTURAL CONTEXT

Artists and designers do not make work in a bubble, isolated from other practitioners or from culture, politics and society. Instead, exciting and creative work comes about through engagement with the world around you and an awareness of contemporary practice. For this reason, interviewers want to see applicants who demonstrate curiosity and a passion for their subject, both in the way they speak about their portfolio and in the work itself. An integral part of becoming a critical and self-aware aspiring practitioner is having a sense of what's going on in your field and in the wider creative and cultural realm. Obviously, this doesn't mean that you have to make work that is ostentatiously trendy or that resembles the work of other artists and designers, but you should be able to talk about and think about issues in contemporary practice.

# Christine McCauley, senior lecturer, BA Illustration, University of Westminster

'What you're looking for in an applicant's portfolio is a knowledge of and enthusiasm for the subject and an awareness of the field more generally. Some students know very little about the subject and expect a course to provide everything. Clearly, these students are going to be much less attractive than students who demonstrate the enthusiasm, motivation and initiative to find things out for themselves. So as an interviewer, you're not looking for someone who simply does the projects they're set without any reflection and without doing any independent research.'

Knowledge of historical practice in art and design is also vital to becoming a rounded and effective practitioner. This does not mean an academic, highly theoretical understanding of art history is necessary, or even desirable: interviewers will be looking for an applicant who is able to refer to past artistic movements in a relevant, intelligent, critical manner. It is key to demonstrate that you have undertaken independent research that is personal and pertinent to your practice, not just passively absorbed a contextual studies module. So if you are an art student working mainly in moving image, you are perhaps passionate about David Hall or Sergei Eisenstein, but you don't necessarily need to have an encyclopaedic knowledge of Post-Impressionism.

In the images opposite from a foundation course fashion project, the designer has referred to constructivist textile, garment and graphic design. The use of a range of original early 20th-century imagery in the form of mood boards demonstrates an ability to identify and research an idiosyncratic theme. The photo shoot provides evidence of made-up garment designs, indicating an ability to translate historical influences into relevant, contemporary fashion. The use of a modernist architectural setting which links to the original research is important, as it shows an awareness of the interconnectedness of art and design practice, and of 20th-century design history.

Students commencing specialist studies in art and design might indicate their cultural awareness in some fairly straightforward ways, by documenting gallery visits in a sketchbook, for instance. If you are interested in fashion, you might take photographs of people's clothing in clubs or on the street. Equally, if you have an esoteric interest in photographing abandoned buildings, you should definitely include these images in your portfolio or sketchbook.

Foundation students are in the process of developing an understanding of their subject, so they are expected to demonstrate a growing awareness of contemporary practice within their chosen field. For this reason, as a foundation student you should have some knowledge of artists or designers working in your discipline and be able to express opinions about them, and perhaps even demonstrate how they have influenced your own work. An understanding of the conventions of your specialist field

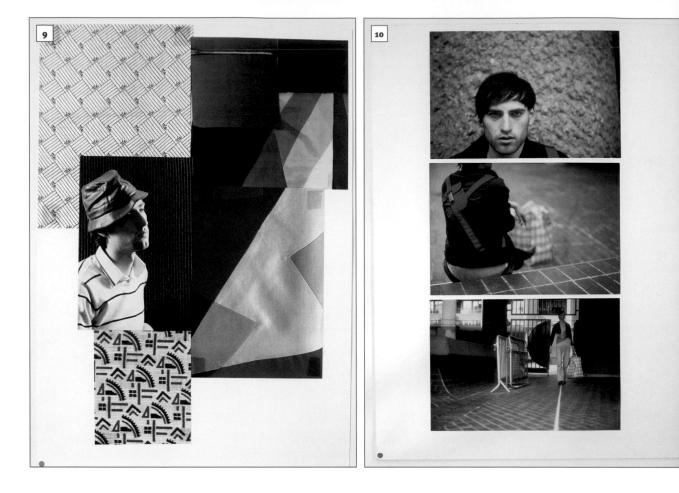

is also desirable. Fashion designers, product designers and fine artists all undertake research and develop ideas from an initial concept, but the ways in which they might present and conceptualise their research and development is likely to be quite different. For this reason, it is a good idea to find out how other practitioners in your field document and present their work. Based on this research, make a judgement whether mood boards, a concept model, annotated sketches or developmental photographs are the best way of explaining your ideas. Quite often, the presentational or design development conventions of a particular discipline exist for quite sensible reasons. For example, product, furniture and interior designers tend to emphasise three-dimensional experimentation and the use of maquettes and concept models in developing their ideas, while fashion designers often produce drawings rendered in clean lines in order to show the details and construction of a garment.

## Professor Janet Woolley, illustrator and course leader, MA Illustration, Camberwell College of Arts

'I often do get students that have a very informed approach, for instance I have students that work at the *Association of Illustrators* or have been illustration agents, students that are already illustrators and have a great deal of experience of the field. On the other hand, I have a number that are from fine art courses, textile courses, also graphic designers, who have much less in-depth knowledge of subject-specific issues. In these cases, I would expect them to show a passion for the subject and to have researched into illustration. You can usually see this very clearly in their folders: an obsessive quality, or a tenacious approach to image making that has sometimes been upheld under quite difficult circumstances. They may have a feel for narrative or visual concepts, and in the few cases that they are not art trained but have a degree in philosophy or English, there is evidence of very well-developed writing skills that may support less well-developed visuals.'

As Janet Woolley suggests, it is essential that students demonstrate the initiative to go out and undertake independent research. If you are interested in studying a specific subject and are applying to a course, you should be able to show that you have looked into the field and are genuinely engaged in and enthusiastic about it. At a higher level, students should be able to reflect on issues around contemporary practice with a greater degree of sophistication. Undergraduates and students applying to postgraduate courses will tend to draw on the influences of other practitioners more reflectively – and probably less directly – than students on a foundation course. Nevertheless, it is always positive to demonstrate a broad cultural awareness, an ability to refer to historical and contemporary artistic or design movements and to understand and distinguish between a range of visual languages. Students at BA or MA level may explore the work of practitioners outside their immediate fields, while other cultural, social or political input may inform the work of more developed students. For example, interior designers with an interest in public space might well explore works of social theory, while product and fashion designers might engage with ideas around sustainable design and manufacture.

# TECHNICAL ABILITY

Students sometimes obsess over a perceived need to demonstrate high levels of technical ability in their portfolios. Technical and craft skills such as being able to paint in oils, embroider, etch, weld or whatever it may be are important in that they allow you to express and develop your ideas, and make well-finished and convincing products and designs. However, interviewers won't necessarily be interested in seeing these skills in isolation. It is much more important to show your technical skills used thoughtfully, in a way that relates to your emergent practice and to what you are trying to achieve as an artist or designer. It is often useful to think about why you have chosen to explore a particular technique or method of production, and how this relates to the visual and conceptual ideas you are trying to communicate in your work.

It would be reductive to talk about the pieces opposite by Andy Charalambous simply in terms of skill. But what is interesting in the case of Andy's installations is that his developed technical abilities are used in a thoughtful and considered manner to work through conceptual, formal and aesthetic problems. Indeed in Andy's work, the process of making is integral to the conception of the art object. It is only through experimenting with various materials and technologies that the finished form emerges from initially abstract or theoretical notions.

It is important to understand that when interviewers look through your portfolio, they will want to see evidence of technical skill used creatively. For example, it may be good to show that you have studied colour theory on a foundation course, perhaps by including a series of formal exercises in colour. But it is better still to show that you have gone on to apply this technical knowledge in your subsequent work by producing bold and exciting paintings, print designs or light installations. Those outside art and design will often see 'skilled' or highly finished images and artefacts as being of inherent value, even if the work is highly derivative and otherwise not very interesting. Being a fantastic draughtsman, having strong three-dimensional making skills or sophisticated CAD skills are desirable and marketable qualities as long as you show these skills used in a creative, informed and original manner.

**Illustrations 11, 12**

*In this piece by Andy Charalambous, entitled* Rejected, *vessel-like artefacts have been produced by inflating pouches of porcelain, in a process invented by the artist. The resultant objects have a semi-organic quality reinforced by their being placed on a bed of leaves.*

## Core Skills

## Elinor Renfrew, fashion course director, BA Fashion, Kingston University

'*An ability to draw from life is essential, and we rely on this skill to deliver a specialist curriculum, for example with classes in fashion illustration. A developing understanding of three dimensions is important, and we would hope to see some experimentation with draping to create shape on the stand in an applicant's portfolio. However, machining skills beyond basic lockstitch for seams would not be expected. Unfortunately, the theory of colour, which is fundamental for fashion designers, is disappearing from the curriculum. It should be evident in foundation portfolios alongside core skills such as perspective and life drawing.*'

While students applying to BA courses are not expected to have the developed technical skills of a professional artist or designer, certain key abilities are desirable in a student's portfolio, as they represent a set of core skills necessary to access a more specialist curriculum. These key technical abilities are as follows:

- An ability to draw accurately, including an understanding of perspective and foreshortening. Evidence of this should be demonstrated in drawings from life (observational drawing), but perhaps also in imaginative drawings or designs which may reference photographic and other sources.

- A knowledge of colour: understanding how colours can be mixed to achieve different hues; how they can be neutralised by adding a complementary colour; the difference between primary, secondary and tertiary colour; and the difference between a hue, a shade and a tint. The confidence to use colour compositionally, to achieve dynamism and balance a composition.

- An ability to research ideas by making drawings and photographs on location; visiting museums; studying artefacts, buildings, interiors and the work of other artists and designers. In the field of design, it is particularly important to develop original research, for example by looking at historical artefacts or objects from other cultures, or by looking at art and design outside your immediate discipline. This will prevent your work becoming too derivative of contemporary designers in your field. In fine art, practitioners may well make drawings, photographs and models as they plan a new piece of work, but they are also likely to undertake research in the form of reading art theory and philosophy.

- Experience using a variety of media, materials and processes as appropriate to your work and chosen area of study.

### Illustrations 13, 14

*These pages from the A-level sketchbook of Theo McCauley Bowstead demonstrate his ability to tackle a single subject matter using a variety of approaches. The oil-pastel study in image 13 demonstrates sensitive observational drawing skills as well as an ability to describe form and shadow using accurate colour-tone. The collage and print techniques Theo uses in other studies indicate a liveliness of approach and an ability to think about decorative and compositional effects.*

This list gives students applying from school some indication of what interviewers will hope to see in a confident A-level portfolio. However, at this early stage of study, demonstrating a curiosity about the visual world and an ability to communicate visually are most important. For this reason, it is important to show a diversity of work using different processes and approaches. Where possible, you should include records of work in both two and three dimensions in your portfolio. For instance, if you have made sculptural pieces, site-specific constructions or costumes, make sure you have good-quality, well-mounted photographs of this work. It is also a good idea to demonstrate an ability to tackle a single subject from various points of view, for example by representing a figure in different ways using a range of media. The figure might be depicted as just a simple shape silhouetted against a window, a linear shape in motion or as close-ups of various parts of the body. Interviewers want to see that you have used drawing and painting creatively to explore different ways of seeing and experiencing the world. The tutors going through your work will be looking for images that are original and fresh, so do not include drawings of cartoon characters. Cartoon drawings are almost always reliant on existing stylistic clichés, and are very likely to put off interviewing tutors.

## PROCESS

When putting together a portfolio, we often think that the end result of a project is the most important thing to highlight. However, interviewers will often find the process through which you have developed your ideas as interesting – and perhaps even more interesting – than the resulting finished piece.

These images from a foundation-level interior design project by Rhonda Sargeant demonstrate an ability to conceive of and play with three dimensions in a very free and creative way. While the paper maquettes in illustrations 15 and 16 are very abstract, as Rhonda's design process

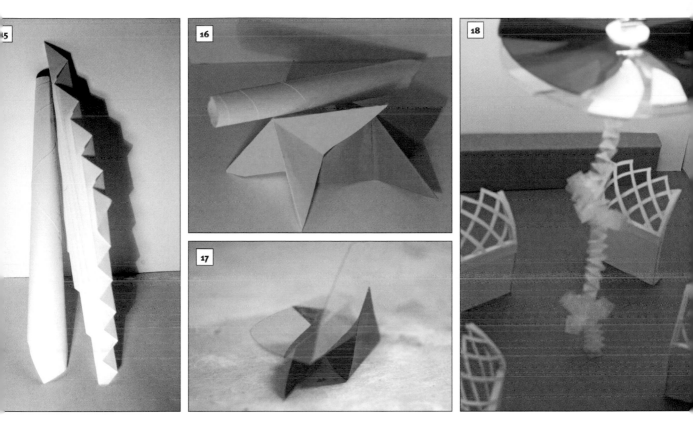

**Illustrations 15, 16, 17, 18**

*Rhonda Sargeant's confident, visually striking three-dimensional experimentation is the first step to developing a resolved design concept.*

progresses, in images 17 and 18, the three-dimensional forms begin to be resolved into more concrete ideas for interior interventions – in this case an exhibition space and concept for a bench. Providing evidence of how you developed an idea gives interviewers an insight into how you think through and resolve problems. Documentation of process helps indicate a rigour to your approach as a designer or artist, and also underlines the originality of your work.

Students working in different subject specialisms will not approach the documentation of process in the same way. In fashion, as in other design disciplines, it is normal to present the research and development process using mood boards. In fine art and illustration, however, the convention is to document developmental work in a sketchbook or even in a loose folder.

**Illustrations 19, 20**

*In this first-year BA fashion project by Jay McCauley Bowstead, initial inspirational images are drawn from old knitting magazines and photographs of vintage garments. Photographic imagery, drawings and graphic elements are used to define a mood and colour palette that go on to inform the designer's experimentation with knit.*

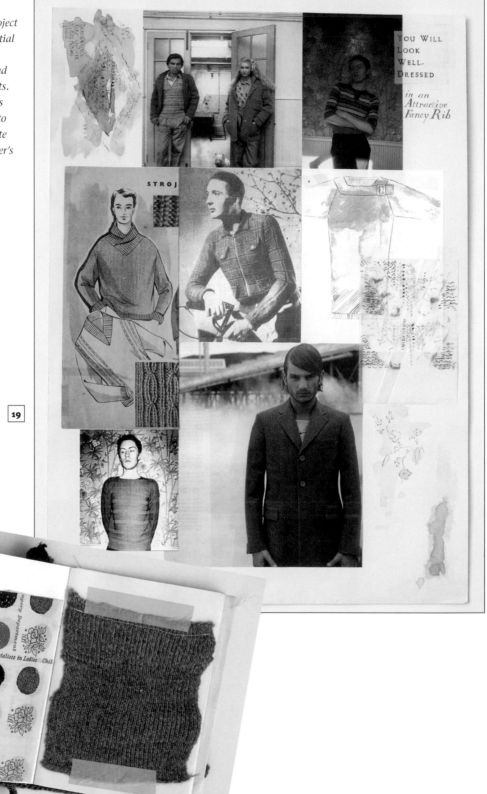

19

20

# PRESENTATION

## Elinor Renfrew, course director, BA Fashion, Kingston University

'Presentation is definitely an important factor in making judgements about an applicant's portfolio, particularly for projects such as photography and communication design. Overall presentation of the portfolio is also obviously key. We limit portfolios to one A2 or A3 portfolio and two of the best sketchbooks; no garments, only photographs – as you would for sculptures. Presentation of sketchbooks and samples of work is a consideration as well, so no plastic carrier bags from high street stores, no random textile samples falling out of sketchbooks, no personal stuff dropping out of portfolios – hats, scarves, train tickets, notes for the interview and lists have all been left behind after interviews.'

When it comes to presenting work, some of the most important considerations are also the most simple. Lecturers will be going through hundreds of folders, so it is important to ensure your portfolio is easy to handle. Small pieces of paper that aren't mounted and rolled-up samples of work are not going to endear you to your interviewer; worse, they may not even look at them. Your portfolio's appearance may be taken as a signal of how you feel about your work: a dirty, tatty, jumbled or poorly presented folder gives the impression that you don't care about its contents and as a result, the interviewer probably won't either. The points Elinor Renfrew raises are interesting too. Storing samples of work in an old carrier bag may seem insignificant, but these choices are effectively decisions about presentation and will have an effect on the way content is understood and perceived. Presentation serves the function of framing and clarifying content, as described in the previous chapter, and this can be done in very simple ways – most obviously by grouping work from the same project to demonstrate that it belongs together and by ordering work to suggest a progression of ideas.

At an earlier level of art and design education, certainly for applications to foundation courses, simple and visually uncluttered presentation is preferred. While applicants from school may have good image-making

*In these pages from Theo McCau-
ley Bowstead's foundation portfo-
lio, punchy images with a strong
sense of colour and humour are
presented simply, with as few dis-
tractions as possible. Illustration
21 features initial observational
drawings made in the first stage
of designing a limited-edition
fanzine. Illustration 22 demon-
strates how Theo developed double-
page spreads for the publication by
scanning, layering and manipulat-
ing the original drawn images,
producing quirky, playful composi-
tions. Ordering pages of a portfolio
sequentially in this way leads the
interviewer through your design
process. While the presentation
of Theo's work is very simple,
the composition, balance and
layout of the sheets have been
carefully considered.*

skills and even quite good conceptual skills, their sense of layout and presentation will almost certainly be underdeveloped, and tutors want to get a sense of the work with as few distractions as possible. Although they may not always be explicitly articulated by recruiting colleges, conventions regarding presentation are in fact quite narrow and prescribed, particularly when it comes to two-dimensional work with a fine-art focus. Students typically mount their work on high-quality white paper or thin board, orienting all the sheets in the same direction, be it portrait or landscape. Pieces of work are placed centrally on the mounting paper, with an equal space at each side, but slightly more space at the bottom of the page than at the top, as this gives a more positive feeling to the composition of the page. They are fixed in place with double-sided tape or mounting spray. If several pieces of work, perhaps developmental drawings or experimentation with a range of media, are mounted on one page, students avoid visual confusion by arranging them centrally along imagined (or very faintly drawn) horizontal and vertical lines.

Beware that presentation that looks simple is not necessarily simple to achieve. Common mistakes include leaving too much space between images on a page, thereby leading the viewer to focus on the gaps, or using unusual and distracting presentational devices such as double-mounting on coloured paper. The habit of making notes on developmental work encouraged by some school curricula can also cause problems. Notes in your sketchbook are perfectly acceptable, but consider if it is really necessary to write 'and then I tried using thick impasto paint' on pieces of portfolio work, or if it is self-evident. Unless it is a considered part of a composition, text should be avoided, as it has a tendency to detract from your work.

There is also a psychology of portfolio presentation to be taken into account: remember, most interviewers will want to be impressed by your folder (it's actually quite depressing to see poorly considered, inappropriate work). With the proviso that you have relevant, strong pieces to start off with, manipulating the order of your projects can be a surprisingly effective way of improving the response to your portfolio. Experienced tutors will often advise arranging your work in order to gradually build the viewer's positive response. For example, to demonstrate that you are

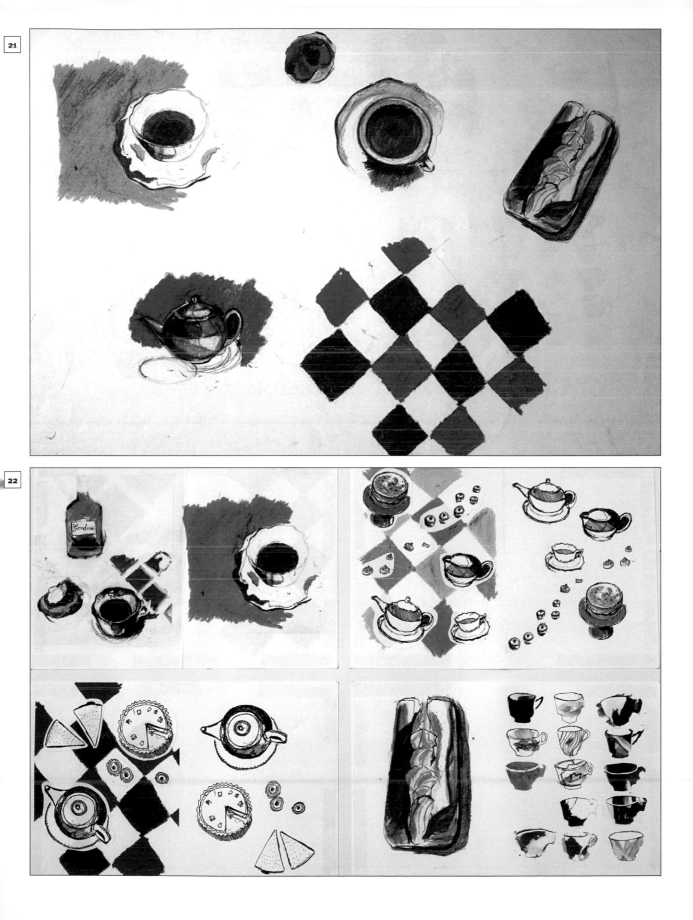

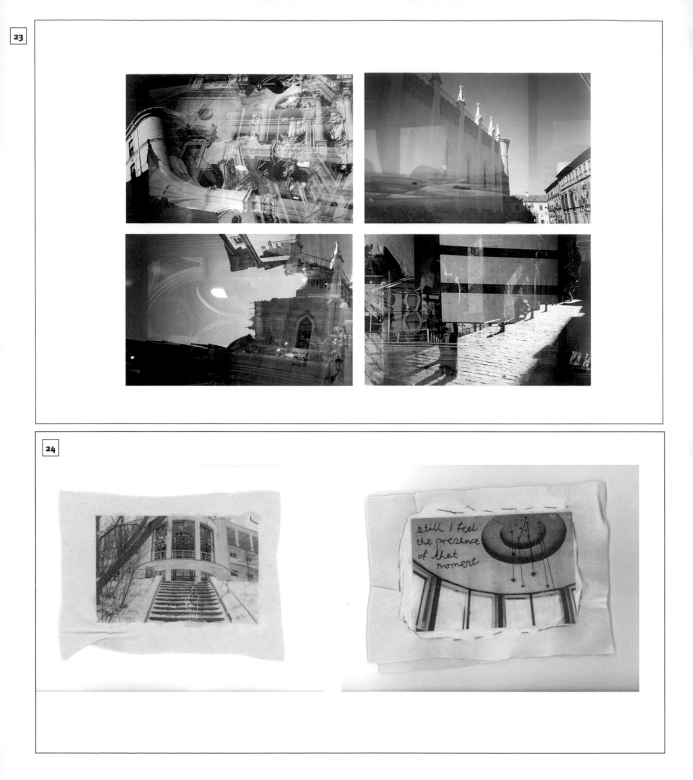

**Illustrations 23, 24, 25, 26**

*Images from a PGCE course application by artist Gemma Walker. The diversity of Gemma's artistic practice is indicated in her PowerPoint presentation of works using a variety of techniques, including Polaroid and wet photography, print, embroidery and drawing. In the context of a teacher training application, Gemma is demonstrating an ability to work experimentally using different processes, skills that can be applied to engaging students across a broad curriculum. By editing her portfolio quite strictly, she provides a snapshot of her practice that acts a starting point to a discussion of her approach to art and teaching, and reinforces her verbal presentation.*

worth taking seriously, it is a good idea to start the folio with a strong, robustly researched, well-developed piece that, nevertheless, isn't your very best work. The next piece or project, however, should be a knock out – original, with strong visual impact and a good sense of your working method. If all goes well, this piece will resolve the interviewer's mind about your candidacy. Having proved your ability, you can include projects that give a more general idea of your experience and the diversity of your practice in the rest of the folder.

As students progress to a higher level of education, presentation becomes more personal and specialised. Applicants to BA courses are expected to have a certain degree of sophistication and at this level there should be an aspiration to presenting work professionally, as we have discussed before. When presenting projects focused on your chosen specialism, it may be useful to consider how other practitioners in the field document and organise their work. At the same time, it is essential to maintain a feeling of individuality in your portfolio, so if your work is about delicate hand-rendered drawing, for example, a slick computer-generated finish with flashy graphics may not be appropriate.

While it is essential to edit and present your portfolio before an application, it is also important not to over-edit. Just because you are applying for a graphic design degree, that doesn't mean you shouldn't also include fine art projects, three-dimensional work or life drawing. Almost all art and design courses will be interested in seeing that you have a broad background, with experience of observational work and colour theory, for example. More generally, interviewers will want to get a sense of the areas you have covered in your previous studies and how you have approached a variety of diverse projects.

## Andrew Foster, illustrator and senior lecturer, MA
## MA Illustration, Central Saint Martins

'We take students on to the MA course from a variety of backgrounds. Maybe they have studied ceramics, fine art, textiles or theatre design, in which case they will be bringing a very different set of skills to someone from a traditional drawing-based illustration course. So sometimes, we are looking at students who want to redirect their existing work into a viable [illustration] practice.

If we were looking at the portfolio of someone who had left college and had been working in the field in quite a commercial way, we would want to see that they had been continuing to develop more personal work outside their professional practice, or at least be attempting to re-direct their practice.'

Practitioners with professional experience who wish to re-enter education may have different concerns to students who have progressed directly from one level of study to the next. Applicants are often looking to change the direction of their work, or even to move from one discipline to another. If you are a more experienced designer or artist, interviewers will want to see a body of work that is representative of your practice since graduating. If you have been out of college for some time, it is certainly a bad idea to present your graduate portfolio unedited and without additional work, as it implies that you have been inactive for that period. For those who have been operating in a quite commercial context, the inclusion of more personal and reflective work may be necessary to support the professional portfolio. In this way, applicants can demonstrate both knowledge of professional practice and a capacity to research and develop concepts with a greater degree of depth. Similarly, it is necessary for those who intend to change disciplines or re-focus their work quite radically to demonstrate an evolution towards a new approach and an attempt to engage with the concerns and methodology of a new field.

# PORTFOLIO PRESENTATION BY LEVEL

The following section is divided into the three main levels of art and design education – foundation, BA and postgraduate degree – with specific advice aimed at students applying to each level.

## Foundation courses: entering art and design education

Art and design students in the UK very rarely progress directly from secondary education (high school) to degree-level study, with the exception of those in Scotland, where the four-year European model for higher education is followed. Instead, one-year broad diagnostic preparatory courses are the norm. Known as foundation courses, they function as a bridge between a generalised academic curriculum in school and specialised art and design education. More particularly, they give students experience of a range of art and design disciplines taught by specialist practitioners. The value of this sort of preparatory course is twofold: firstly, it typically produces a much higher quality of candidate than would emerge from a school setting. Secondly, by allowing students to try a range of disciplines, the foundation course helps individuals identify which field of study at degree level is most appropriate to their aptitudes and interests. Alternatives to the foundation course in Britain include BTEC National Diplomas for post-GCSE students and access courses, typically for more mature students.

In other European countries, including France and Ireland, the first year of a four-year degree course acts as a foundation year, and is sometimes referred to as the core year. Students are introduced to key visual concepts as well as approaches to research, making and process, and become acquainted with a variety of disciplines within art and design. While this chapter refers to applications to foundation courses, the information and ideas outlined are equally applicable to students entering a diagnostic first year in Ireland, France, Scotland or elsewhere.

## Portfolio applications

Taking the first steps into the word of art and design education can be a daunting and confusing prospect both for school leavers and more experienced mature students. The school experience is often geared towards pupils continuing their studies in a conventional 'academic' context and formal qualifications are valued very highly as passports to good-quality tertiary education. Conversely, even the most prestigious art and design foundation courses are much more concerned with the quality of an applicant's portfolio than with A-level or GCSE grades. However, with growing numbers of students interested in studying the visual arts, foundation courses have become increasingly competitive, especially at the most well-known and well-connected institutions. For example, some of the most oversubscribed courses (particularly those in London) have taken to pre-vetting applicants' portfolios before deciding whether to grant an interview, or alternatively subject applicants to various successive stages of portfolio presentation.

Reading through the previous sections of this chapter, you will have developed an understanding of the sorts of qualities and skills foundation courses are looking for in an applicant's portfolio. It is important to remember that colleges don't expect you to be a fully formed practitioner at this early stage of your art and design education. They are looking for students with a range of developing interests, abilities and skills that can be focused, cultivated and polished in the course of the academic year. To sum up, the key components of a strong portfolio application to foundation are as follows:

*Flair* An ability to produce work that has strong visual impact, is original and expresses something of your personality as a practitioner, and to demonstrate your imaginative and creative capacities clearly through your portfolio.

*Diversity* An understanding of and familiarity with a range of practical art and design activities such as drawing, painting, collage, basic photography and working with various materials, including in three dimensions.

*Context*   An awareness of art and design practice historically and in the present day. An ability to relate to and draw influences from other artists and designers.

*Technical Ability*   Possessing the core skills of observational drawing, composition and colour to communicate your ideas effectively and form the basis for further specialist study.

*Process*   The ability to demonstrate the evolution of a project from an initial concept by undertaking first- and second-hand research, experimenting with materials and developing ideas through drawing and sketchbook work.

*Presentation*   Simple but considered presentation with images carefully composed on the page along vertical and horizontal lines. Organisation of the portfolio so that it leads the interviewer through your projects logically, giving an insight into the process and development of your work.

## Portfolios for degree applications

Moving from general art and design education to a specialist degree course can represent quite a significant shift. Lecturers will, as we have discussed, want to see a broad range of general or core skills in your application portfolio. However, knowledge of and enthusiasm for your specialist field are also important, and there should certainly be a number of projects in the portfolio that concentrate specifically on the subject area in question – two or three at the very least.

Provision of specialist tuition on foundation courses is sometimes patchy, and if you are coming from a smaller course you may find yourself applying for a degree in a subject for which you have received little previous teaching. This needn't be an enormous problem, as degree courses will not expect fully formed designers or artists. What they seek are students who have explored and thought about the discipline, producing work that documents this process. For example, furniture or interior design courses will want to see applicants who have experimented

extensively with three-dimensional form; graphic design courses look for students who are interested in communicating ideas in innovative ways, and so on. For this reason, sketchbooks should include information pertinent to your chosen specialism: your influences, practitioners you have researched, books read and exhibitions attended.

## Clare Law, artist and lecturer, Wimbledon College of Art and The Working Men's College, London

'It is good when students really think through their applications to BA courses, but there is a tendency for foundation students to put down a few prestigious names on their application forms, sometimes without even having visited the college in question. Clearly, this approach is deeply problematic, as students may be poorly suited to the institution and course to which they have applied. You don't, for example, want to send a painter to a fine art course that is primarily focused on video and installation. There is a danger with early applications that students haven't had the opportunity to find out what their particular discipline is all about or to visit various universities.'

As Clare Law points out, one of the most important aspects of a successful application at BA level is to make sure that you are applying for courses appropriate to you. Students can become fixated on applying to a high-profile institution they perceive as being particularly prestigious. While colleges such as Central Saint Martins may offer excellent courses in many subjects, as with any art school or university there is a good deal of variance between different courses and at different levels. It is important to remember that degree courses cannot simply be ranked like football teams: a particular BA programme may be well regarded, with rigorous standards and successful graduates, but that doesn't necessarily mean it is the right one for you. For example, certain courses may have a reputation for their highly conceptual and intellectual approach, while others are more focused on producing skilled and employable graduates. Similarly, degree programmes with the same name don't necessarily offer the same syllabuses, equipment or approach to teaching. If you are passionate

about printmaking, it is sensible to make sure that the institution you're applying to has a well-resourced print room. If you rely on lots of critical input from other students and lecturers, don't apply for a degree course that favours self-directed or remote learning. By visiting various colleges and talking to lecturers and students, you will not only develop a clearer idea of the courses that are most appropriate to your sensibility and needs, you will also discover what sort of student the college is looking for, and their expectations of you and of your portfolio.

### BUILDING AN UNDERGRADUATE PORTFOLIO

In an academic context, the portfolio is normally the basis for continuing assessment, augmented by additional research and development materials that might sit outside the folder, perhaps in the form of sketchbooks or similar. But beyond its formal assessment function within a degree course, the portfolio is also a useful tool for students in its own right. As a student, you don't always realise that beyond any academic concerns, it is in your own best interests to put together a portfolio as you progress through the course. It allows you to see how projects sit together as a body of work, rather than thinking about them as individual, unrelated modules, which is quite an artificial academic construct. Moreover, building a portfolio helps you to develop a sense of ownership of your work, and critical self-awareness.

Students should use their portfolio to reflect on their work. Ask yourself, what are your strengths? Your weaknesses? And perhaps most importantly, what are you interested in? What is the personality of your work? By looking at the diverse pieces or projects you have made over a term or the length of the course, you can get a much clearer and more objective sense of your developing practice. Almost certainly, you will notice that specific themes, interests and strengths assert themselves in apparently unconnected projects. Equally, if there are gaps and weaknesses, you can identify and rectify them. By reflecting on your body of work, you can better consider how you will tackle future projects and make better decisions about the direction of your nascent practice as a result.

## PORTFOLIOS FOR POSTGRADUATE APPLICATION

Students applying for MA courses are working at a high level and usually pursuing a defined line of enquiry. Their portfolio is less likely to be oriented towards the marketplace, but should rather show strong personal concerns and a developed sense of practice within the subject area. There is an expectation that MA applicants should demonstrate a high level of originality, innovation, experimentation, and academic and intellectual rigor in their portfolios.

Individual students' portfolios and applications are likely to differ considerably depending on the character of the postgraduate course for which they have applied. So it is of key importance that students research courses during the last year of their BA, or in the case of graduates, when they seek to re-enter education. Students may need some time, and perhaps guidance from lecturers, to properly consider the requirements of their chosen postgraduate programme, and to develop the appropriate portfolio.

Students applying to study at postgraduate level often do so because they are seeking to develop their practice in a new direction, or perhaps even to move into a new discipline. For applicants jumping ship from the specialism of their undergraduate degree to a new discipline, the change of direction can work either to their advantage or disadvantage. For example, MA lecturers may be keen to take on students from diverse backgrounds in order to encourage a broad range of conceptual and technical skills on their course. However, any student seeking to move from one field to another would need to demonstrate a sound knowledge of their new area of study, and an ability to work in that area at a high level. These students should, of course, be mindful that they might well be competing for a place with someone who has completed an undergraduate course in the specialism. A change of direction should preferably be demonstrated to have evolved, rather than representing a radical change.

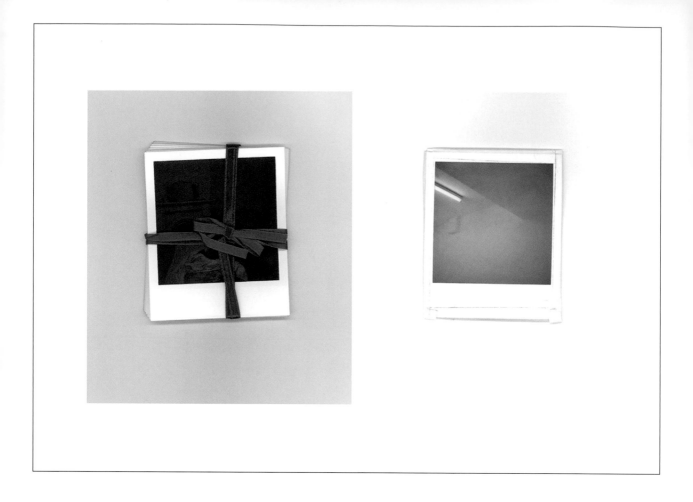

## Gemma Walker, artist

Gemma Walker is an artist with a background in arts education, and a PGCE student at the University of London's Institute of Education.

'During my PowerPoint presentation, as well as showing a range of pieces that demonstrated my skills in photography, printing, drawing and film, I also talked about my dissertation, which was about the role of the camera in performance art. I showed these works which were made alongside the dissertation: a series of Polaroids of performances that were installed in such a way that you could only see the setting of the performance – so it's about the performance being implied, but at the same time you're denied actually seeing it. The pieces I presented were chosen to show a broad picture of me and my work; I wanted to show that I had academic skills, that I had hand-drawing skills, conceptual skills and that I could

usc a range of different processes. At the same time the individual pieces related to one another thematically and visually, because I wanted the presentation to make sense as a whole.'

As Gemma Walker underlines, in the case of applications to postgraduate teaching courses there are some specific considerations regarding the portfolio – or in this case a PowerPoint presentation – that differ from presenting your portfolio in another context. Many MA courses will be looking for a very personal and distinctive approach to practice. However, in the case of teacher training courses, interviewers are concerned not only with understanding the personality of your practice; they will also want to see that you have a range of technical and practical skills, particularly core image-making skills, that you can use to engage students in the curriculum. At the same time, verbal presentation skills and an ability to convey themes and ideas in art are also clearly very important. And finally, as Gemma suggests, it's a good idea to convey a sense of a solid academic background in addition to your subject-specific skills.

## Summing Up

As we have discussed, portfolios in education will differ considerably depending on your level of study, the particular discipline within art and design you intend to pursue, and of course the personality of your work. However, irrespective of level of study or subject, when academics and interviewers are asked what makes a strong portfolio application, certain themes reassert themselves with surprising consistency. To sum up:

*Flair* Interviewers want to get a sense of your individuality from your portfolio. Flair can be demonstrated by showing that you can come at a design problem from an unexpected angle, or that you can see (and represent) the world in an unusual way. Flair often manifests itself when things that wouldn't normally go together are combined, or when everyday things are transformed. At its most fundamental, flair

is about having the confidence to make work that really communicates your personality.

*Cultural context*  It is important to demonstrate a curiosity and passion for your subject. That means being interested in other practitioners in your field, and actively and independently seeking out the work of other artists and designers. As well as knowledge of contemporary art and design, students should demonstrate knowledge of relevant historical practitioners and movements. You aren't expected to have an encyclopaedic knowledge of art history, but you should be able to point to key influences on your work. At an early level of art and design study, cultural awareness might be indicated by documenting visits to art galleries and compiling research in sketchbooks. As students advance, their influences should become more focused and considered.

*Technical ability*  Technical skills will obviously vary enormously between subjects and individual students: the important thing is not to obsess over developing high levels of skill without any thought of how to use them. Interviewers will want to see a level of finish appropriate to the piece of work in question, and it's important to demonstrate technical skills used thoughtfully rather than for their own sake, in a way that relates to your emergent practice and what you are trying to achieve. However, fundamental to all levels of art and design education are core skills: accurate drawing, an understanding of colour, an ability to undertake original research from primary and secondary sources, and an ability to experiment with materials.

*Process*  It is often just as interesting to see the process of developing a concept as to see its final manifestation. In design disciplines such as product and furniture design, interior design and fashion it is common to include pages of developmental work in your portfolio with images of maquettes, concept models or work on the mannequin to indicate how an initial idea evolved. In other areas, it is more usual to include drawings and research in sketchbooks.

*Presentation*   As students become more advanced, their approach to presentation will become more personal and perhaps more complex. For applications to foundation and BA courses, the most important factors are that work is presented cleanly, simply and neatly; is securely mounted (almost certainly) on white paper; and arranged in projects so that the interviewer can understand how various pieces of work relate to one another. Edit work so that it is not repetitive: for example, don't include several prints or drawings that are virtually identical, unless of course that's the point of the work.

# SPECIALISMS

This final chapter is designed to help you focus on the particular demands of your discipline. Many of the concepts discussed in previous chapters are relevant across art and design and can be applied in a variety of ways, according to sensibility and specialism. Nevertheless, conventions of presentation and content differ considerably between disciplines, and it is important to show an awareness of them in order to be taken seriously, especially as a less-established practitioner. This chapter conveys the expert advice of the employers, agents, academics and practitioners who have contributed to this book. However, it is intended to be used as a broad and general guide, rather than a set of prescriptive formulas.

Today, many artists and designers work in a way that straddles traditional divisions – film-makers may come from a fine art background, painters may have studied illustration or graphic design, and practitioners will often produce work that sits between two related fields, such as fashion and textiles, or interior design and architecture. If your work spans media and disciplines, it helps to consider how conventions of presentation can be used to frame it in a particular way. For example, if you wish to move from design to a fine art setting, it may be necessary to re-contextualise your previous work, documenting it in a more clean and stark manner, and prioritising conceptual content. Conversely, an artist moving into the world of design should consider issues relating to function, product development and market. The following sections are designed to indicate the specific demands of major disciplines within contemporary art and design.

# COMMUNICATION: PORTFOLIOS IN ILLUSTRATION, PHOTOGRAPHY AND GRAPHIC DESIGN

## Graphic design

The ability to devise and communicate innovative ideas and the capacity to solve problems creatively, sometimes in unexpected ways, are at the heart of graphic design as a discipline. Talented graphic designers formulate imaginative and elegant solutions to design problems in a way that suits the needs and expectations of their clients. It is no mean feat to foster good relationships with your clients and convince them of your design solutions, while simultaneously producing original, exciting and effective work. Graphic design is by nature a collaborative process in which you as a designer have to pitch projects to clients, come up with alternative solutions and respond creatively to questions or criticisms off the cuff. In this context, your portfolio is an incredibly important tool, a prop almost, that allows you to prove your track record as a designer by providing the visual backup to your verbal presentation.

Your portfolio offers prospective clients a representative selection of your work, demonstrating the breadth of your experience and abilities. Interviewers will want to have a sense of the companies you have worked with previously and the range of designs you have produced in different contexts, so you might wish to show examples of branding, motion graphics, web design, print, illustration and so on. Featuring a variety of design solutions and techniques in your portfolio helps suggest possible design solutions to new clients: previous projects can inspire your prospective clients by giving them a sense of what is possible, technically and creatively, and encouraging them to visualise a finished outcome. Depending on the nature of the interview, you may choose to present a slightly different mix of work, perhaps showing more of your corporate projects to one company or client and more creative work to another.

**Illustrations 1, 2, 3, 4, 5**

*Graphic designer Charis Theobald demonstrates her ability to devise a range of design solutions involving innovative approaches to type, layout and printing techniques as well as materials used in innovative and unexpected ways. Charis's portfolio displays the variety of her work, as well as her ability to respond to the needs of her clients. At the same time, there is a sense of consistency and a strong personal style over diverse projects.*

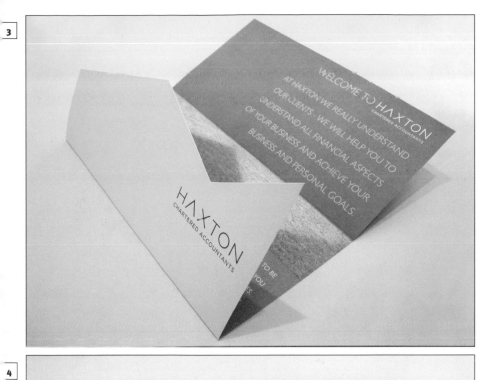

## PHYSICAL AND ON-SCREEN PORTFOLIOS

As a professional graphic designer, it may often be appropriate to present your portfolio on-screen using your laptop in an interview situation. This is particularly true for meetings with clients and in a business context. If the majority of your work has been generated using various computer programs, as will be the case for most designers, the difference between presenting your physical portfolio and an on-screen version may be minimal. However, this approach clearly won't be appropriate for everyone: if, for example, print processes are very important to your work, or if your portfolio includes hand-rendered type and original drawings, either a conventional folder or bound book are likely to be more suitable. Whether you present your portfolio on-screen or in physical form, bringing some interesting objects with you – beautifully printed brochures, samples of embossing or innovative packaging – can be a good idea, as interviewers and potential clients often respond well to something tactile (see illustrations 1, 3, and 4).

## FREELANCE

# Charis Theobald, graphic designer

Charis Theobald is a graphic designer with extensive experience across branding, print and web design. She is co-founder of design practice Studio Brink (see illustrations pp.106–7.)

*'If you are working independently, or as part of a small start-up, remember that you have advantages over larger companies. You are more flexible, and probably more competitively priced. But you will have to actively hunt for clients and therefore innovative approaches to promotion are vital; generating word of mouth and attending networking events are all important. Some of our best clients at Studio Brink were companies who we had met through networking events and subsequently presented work to.'*

Graphic designers working in a freelance capacity will tailor their portfolio presentations to the needs of the particular company or organisation they are approaching. A good way of making a personalised approach to a potential client is presenting a selection of your work as a PDF, choosing

the work most relevant to the application in question. PDFs should be prefaced with a page including your logo, name and contact details, and should end with a CV (see chapter two for more information). However, as Charis Theobald suggests, before making a pitch to a potential new customer it pays dividends to get in touch with them and find out what their needs and aims as an organisation are. Freelancers and small start-ups need to seek new work constantly, but cold approaches to companies are much less likely to be successful than if you have already established a relationship with an individual within that organisation. In the first instance, freelancers will often seek work with existing contacts through colleagues and friends, but how are you going to make contact with a company in a different industry or one that is based hundreds of miles away? The benefit of formal networking events is that they not only open up a whole world of potential clients, but also force you to up your game in terms of making convincing and professional presentations.

## PROFESSIONALISM

In addition to the creative and artistic aspects of graphic design, practitioners will often require the skills to work alongside and within corporate organisations. As a designer, you may frequently be liaising with and presenting work to clients who have no background in the visual arts. For this reason, as well as producing good work, you also have to develop the ability to justify and sell your ideas in a way that can be easily understood by non-designers. In addition to devising and executing design solutions, practitioners are often dealing with complex strategic problems, producing work on budget, to a timescale and in collaboration with other designers, illustrators and photographers, meaning that they need a whole range of interpersonal and organisational skills.

*In addition to work produced in a corporate environment, agents and employers are often interested to see more experimental work that expresses the designer's personality and ethos. As well as having a strong sense of energy and creativity, these examples of self-initiated creative typography (illustrations 6 and 7) by graphic designer Kirsten Elliott demonstrate cultural literacy in their references to early 20th-century De Stijl and constructivist typography.*

# Carly Broome, recruitment consultant, Major Players Creative Recruitment Agency

'I would advise graduates and those starting out in their careers to get as much experience in professional design environments as possible. More experienced candidates are likely to be confident and to use correct design terminology. Good internships, lasting for months rather than a couple of weeks, may give graduates an opportunity to work on professional projects and perhaps to be involved in making a pitch to a client. Even if an internship doesn't lead directly to a position in the company in question, it gives invaluable experience, which in turn makes a candidate more employable.'

For graduates and less experienced practitioners, there is a vicious circle of trying to find work when employers inevitably want previous professional experience. While some lucky graduates will be plucked from art school by design agencies, the vast majority find their first job through short-term contracts, internships and other informal working arrangements. Having professional work in your portfolio will almost always make you more attractive to employers, as it suggests an ability to come up with the goods. And even those still in the education system can benefit from producing work in a freelance capacity, bolstering their portfolio prior to graduation.

## VISUAL LITERACY AND PORTFOLIO IDENTITY

Since graphic design is fundamentally about ideas, employers and educators want to see good conceptual work, that is, the ability to come up with innovative solutions to design and communication problems. They will also want to see the development of these ideas from initial research and visual investigation, including through drawing. Communication is a fundamental concept in graphic design: in a portfolio you are trying on the one hand to demonstrate a clear sense of your own identity, ethos and aesthetic, and on the other hand to communicate the ethos and identity of the organisations for whom you are designing.

A good working knowledge of programs such as InDesign, Flash, Photoshop, Illustrator and other graphics and web applications are

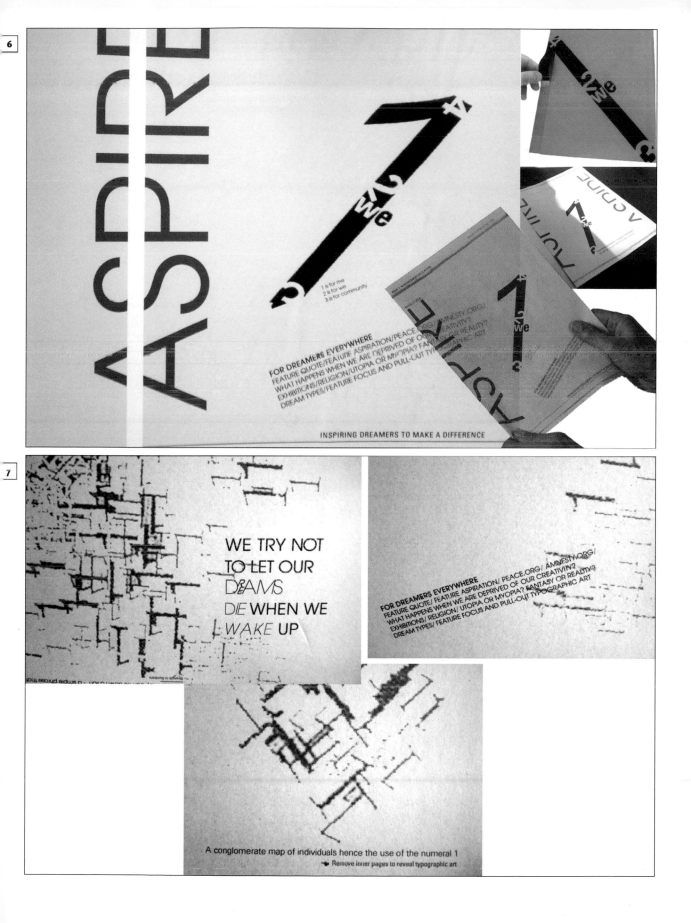

**Illustration 8**

*In contrast to Kirsten Elliottt's more experimental illustrations 6 and 7, illustration 8 displays a high level of finish and professionalism in the context of a professional corporate project.*

fundamental to much contemporary graphic design practice. Nevertheless, in the past five years there has been a reaction to, and move away from, the very consistent finish associated with computer-generated design. An ability to draw and to hand-render type demonstrates a depth of understanding of the discipline; it also allows designers to create more sophisticated images. Therefore, an ability to combine drawing and traditional media with contemporary IT packages has become even more important.

## ILLUSTRATION

While it remains an intensely competitive profession, illustration is currently enjoying a particularly exciting and creative period. Over the past few years, three-dimensional, drawn and mixed-media illustration has been embraced by advertisers, used extensively in newspapers and magazines, and featured in unusual settings such as shop windows and displays. At the same time, a market for fanzines and quirky illustrated books often produced in limited editions has opened up through stores

like Magma in London and other fashionable, independent art and design bookshops. Similarly, graphic novels have gained popularity and the confidence to deal with a variety of serious, political and intellectual themes. Given the dynamic, fast-changing nature of the market for illustration, it is important for illustrators to keep on top of innovations in the field. However, it is rarely sensible or productive to attempt to mould your own work to fit into the niche occupied by another practitioner – not least because that space is clearly already taken. The challenge for those beginning their careers in illustration is to continue making strong, original and creative work, while attempting to find applications that will suit their practice.

Illustrators today work across a wide range of media and formats, from animation, games design and children's books to calligraphy

**llustrations 9, 10**

*Images from the portfolio of Agnese Bicocchi (illustration 10 overleaf). A move away from photography and towards illustration in magazines and particularly in newspaper supplements has opened up an important space for illustrators.*

9

and hand-drawn typography. Practitioners often produce work in two or more formats, for example children's book illustration, handmade greeting cards and paintings to be exhibited in a gallery context. With the diversification and evolution of their practice, illustrators have also become increasingly interested in layout and typography, and many illustrators have a range of graphic design skills in addition to drawing, painting and image making. Illustrators with a developed sense of design find that they have more control over the presentation of their work, because rather than simply supplying an image, they are able to design the whole book cover, magazine spread or record sleeve. At the same time, the ability to handle type, layout and design is likely to open up a greater variety of opportunities than image-making skills alone.

Visibility is perhaps the most important issue for less established illustrators. But with opportunities opening up through the self-publishing of limited edition artist's books and cottage industries making badges, toys and other products, as well as the internet, pop-up shops

Page 6 of 10
22/05/08

Project
TRENCHER'
Lips like Suicide

Client
Southern Records

11

'Lips' is TRENCHER's third album which has recently been re-
leased on Southern Records. I was asked by the labels to create
a promo for the title track from the album. 'Lips like Suicide' is
fast moving, angular, shaped driven piece completed in a short
and sweet three weeks.

and collaborative working, there are many ways you can publicise and
disseminate your work without the need for the infrastructure of an
established company. Of course, many illustrators will be interested
in finding work in a more traditional context, but at the same time as
approaching publishers, editors and agents, it can be a good idea to keep
your portfolio looking fresh and up-to-date by producing your own work
– and hopefully gaining some recognition in the process.

**Illustration 11** *Combining
photography, type, drawing and
collage, Jayne Helliwell's practice
inhabits a space between graphic
design, illustration and fine art.*

## David Bennett, publisher and creative director, Boxer Books

'It is incredibly important to approach the market with some knowledge of it.
Publishers get a huge amount of unsolicited work, and it is almost never looked
at. Publishers are as busy as any industry and know what they want. Start by
researching the market. Choose carefully who you send your work to, and know

why you are sending it to them. Try to make contact by email or phone before sending: find out who will actually look at your work; no point in sending a teenage graphic novel to the editor for baby books. Keep the presentation short, to the point, focused — it is the work that is important. If you get a contract, get someone who knows about contracts, such as a lawyer, or seek advice from the Association of Illustrators to make sure the contract is a good one.'

## ONLINE PORTFOLIOS

## *Agnese Bicocchi, illustrator*

Agnese Bicocchi is an illustrator with extensive experience in editorial illustration as well as a dynamic personal practice.

'In terms of my portfolio, the first thing to say is that I graduated in a time of transition. When I first graduated, portfolio appointments in person were more common; today, editors tend to ask to see my portfolio online, or for example yesterday I was working towards building a portfolio in a PDF form. I find it very interesting and constructive when I do present my portfolio face-to-face, but it is becoming increasingly rare in the world of illustration. And, in a way, my physical portfolio is becoming something more for me, for my own records.'

Online portfolios have perhaps gained greater acceptance and importance in the fields of graphic design, illustration and photography than in any other areas of art and design. Practitioners in these disciplines often work in a freelance capacity and as Agnese suggests, while in the past editors and potential employers would frequently want to have a physical portfolio sent over before commissioning work, today a website is very much the first port of call. Of course, particular clients may well want to see examples of your printed work, and some editors and employers continue to arrange meetings in person in which you present your portfolio. Nevertheless, it is by no means unheard of for editors and clients to commission work solely on the basis of work seen online, whether in the context of your personal website, the website of your

agent, or an alternative online resource such as illustrationmundo.com. For more general information on approaches to freelance working it may be useful to refer back to the Graphic Design section.

## PHOTOGRAPHY

Photographer James Pearson-Howes's practice spans editorial work, music and fashion photography, with clients including *i-D* magazine, *NME* and Atlantic Records. He also regularly exhibits his work, producing personal, idiosyncratic projects – most recently documenting folk festivals and ceremonies around Britain   and limited-edition books. As you can see in illustrations 12–14 (overleaf), it is important for photographers to have a strong and identifiable approach to image making. Photography portfolios and websites should communicate previous professional experience. In the case of an online portfolio, it's a good idea to divide work up into clear categories, such as documentary, fashion and editorial photography, in order to make your site easily navigable. It is also advisable to demonstrate a degree of consistency in terms of style and subject matter, both in order to maintain coherence in your portfolio and to allow editors and clients to develop a clear sense of your work and your capabilities.

Visually, photographers set out to produce a sense of rhythm, contrast and variety in their portfolios, for example by balancing facing pages in their books in terms of colour and composition; mixing vibrant colour with black-and-white images or alternating between single photographs and double-page spreads. Most photographers will have both an online portfolio and a physical 'book', but it is important that these are not too similar in content and layout. Although you will almost certainly have many of your best or most successful shots in both versions of your portfolio, agents and others will want to see a greater variety of work when you present your physical portfolio, so consider including pieces that are works in progress and more personal projects.

As well as specialising in particular commercial areas of the discipline, photographers may also locate their practice in the world of fine art,

12

DONT WEAR A NEWERA CAP IF
YOU NEED MORE THAN A SIZE 8!!!!!...

ME AND OTTO USED TO WALK AROUND WITH
FORKS IN OUR BAGS BECAUSE KNIVES WERE
ILLEGAL. FOUR HOLES ARE BETTER THAN
ONE.

---

13

ONE DAY THE ELECTRICITY IN THE BARBERS
CUT OUT MID HAIRCUT. HALF AN AFRO
AINT FUNNY

*Illustrations 12 and 13 by James Pearson-Howes are from a limited edition fanzine, while illustration 14 is taken from his series* British Folk, *focusing on the strange and colourful folk events and ceremonies that take place around Britain.*

making work to be exhibited in a gallery context. This may require specific and different approaches to presentation and promotion (see fine art section for more information).

**llustrations  15, 16, 17**

*Images in colour and in black-and-white, in different formats, detailed close-ups contrasted with landscapes all create variety and visual interest across James Pearson-Howes's portfolio.*

## Fashion and textiles: portfolios in fashion and textile design

### FASHION

Fashion design is a discipline in which a strong personal sense of style and flair is particularly important. In the same way that a label uses styling and promotion to communicate distinctive aspirational values, fashion designers should employ presentation to express their individual sensibility and 'handwriting' in their portfolios. Graphic design skills including a sensitivity to type and composition are used by fashion practitioners to reinforce the 'story' and identity of a collection or project in their portfolio. Presentation also serves the function of unifying and contextualising designs, illustrations and technical drawings.

In the images overleaf by fashion designer Bonnie Highcazony, notice how a sense of mood has been successfully created by combining photographic imagery, fabric swatches, text and other graphic elements. Equally, Bonnie manages to retain a strong design sensibility across the whole portfolio, while differentiating more commercial projects (illustrations 18 and 19), from more personal and idiosyncratic work (illustrations 20 and 21).

Professional portfolios will, of course, be focused on work designed in a professional context. For this reason, it is important when working for a particular company to ensure that you have copies of any look-books containing your designs, and to keep hold of embellishments, trims or branding ideas you developed as well as retaining your original designs. While the overall emphasis of your portfolio will be on professional projects, when applying for a new position you may want to include work you have produced in your own time. In fact, you could complete a project focused specifically on the company – or more likely the market level of the company – to which you are applying. This

## Weather Beaten

Granola meets grunge. Slouched layers of stone, heather greys and earthy monochromatic shades give the feel of sun damaged garments. Tonal washes and colour stripping on cottons and linens contrast and compliment technical fabrics.

Cover Up for SS08 - colour and fabric

Protect yourself from the midday sun with sheer silk/cotton mixes. Long loose cardigans in a tight stitch shroud the body from damaging rays. Knit is twist dried in stone, heather greys and monochromatic tones, as if aged by the sun. Come the cool summer evenings - just can't bare to don a coat? Wrap up in voluminous, chunky knits. Large loose stitches ventilate and exude comfort.

Whatever The Weather

21

**Illustrations 18, 19, 20, 21**

*Portfolio layouts by designer Bonnie Highcazony communicate a strong sense of mood by combining graphic elements and text with fashion imagery.*

demonstrates an understanding of how your take on fashion and trends can be translated to be relevant to a particular customer or brand. For more creative positions, you might want to include some examples of personal work communicating a strong sense of your own aesthetic and sensibility, which could take the form of a portfolio project, or research and developmental drawings in a sketchbook.

In the pages overleaf from the portfolio of designer Kathy Edwards, working drawings produced in a professional studio context give a sense of how ideas are thought through, by demonstrating how she plays with detail and proportion to develop a coherent range. By leaving evidence of the working

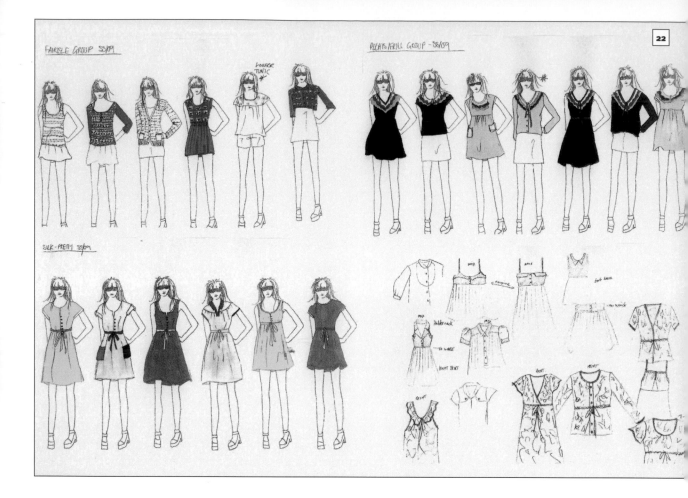

**Illustrations 22, 23**

*Working design drawings by
Kathy Edwards.*

process in her drawings, such as scribbled notes and quickly rendered close-ups, Kathy avoids losing the immediacy of her work. Her quirky drawings express a sense of personality, while also clearly describing decorative and constructional details. At art college, portfolio projects often feature elaborate illustrations in order to communicate the look and mood of a proposed collection, but this is not always necessary in a professional context as you will be able to show interviewers photographs of the made-up garments. To this end, always retain any promotional photographs or images in magazines featuring your work, as they will add cachet to your portfolio.

Less experienced designers are of course likely to have fewer professional projects in their portfolios. Employers and agents will be particularly interested in any work you produced while working in the fashion industry, be it on placement or a temporary contract. Equally, it is perfectly acceptable to include some projects from university in the

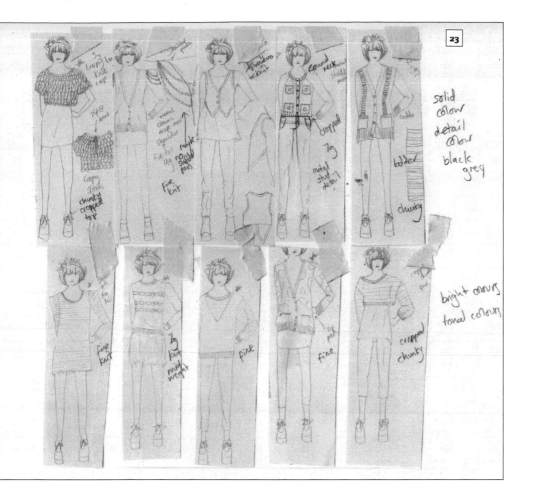

first two or three years after graduating; after this point, it is advisable to reduce the number of pages from your college portfolio to a couple of sheets featuring your graduate collection, if it remains relevant to your current work. It is a good idea to continue producing new personal projects for your portfolio and even mini-projects for speculative applications in those unfortunate periods when you are not working, which are more common for those at the beginning of their careers. Seeking freelance work and asking friends and contacts if they need any help in the studio are also good ways of minimising any gaps on your CV and, perhaps more importantly, keeping your knowledge of contemporary fashion practice fresh and up-to-date. An awareness of what's going on is a valuable asset for an up-and-coming designer, one that should be indicated by a regularly updated portfolio.

## Lauren Dyer, senior womenswear consultant, Denza fashion recruitment agency, London

'Typically graduates will be applying for design assistant jobs, and for this reason employers don't expect to see portfolios which are focused exclusively on one product category, for example jersey or outerwear (the exception to this rule are knitwear graduates, who are quite specialised). Instead, employers are looking for graduates whose handwriting is in tune with their brand and who understand the brand's values and customers. After having worked in the industry for some time designers are likely to become more specialised in a particular area, and in turn their portfolio will become more specifically focused.'

Recent graduates will quite rightly be concerned with presenting a strong and visually arresting portfolio, showing off their developing skills in design. However, while graduate portfolios are often dynamic and exciting, they can suffer from an absence of commercial awareness. Consider which brands you would realistically like to work for, and include mini-projects focused on these companies. A combination of creative energy and an ability to translate your ideas into commercially viable designs is a potentially winning formula. As Lauren Dyer explains, being focused exclusively on a particular product category is not necessary at an early stage of your career, although you may have a stronger feeling for some than others. It is however useful to consider carefully which labels would tally with your 'handwriting' and approach.

A few points to keep in mind:

- Fashion portfolios are typically smaller than in other areas of design: A4 is the norm, and it is very rare to see fashion portfolios larger than A3, except in an educational context.
- Most graduates will be expected to have at least some skill in Photoshop and Illustrator, and InDesign is a bonus. However, there are still companies that rely heavily on hand-drawing and traditional methods, so these skills are valuable too.
- As well as expecting a working knowledge of design programs, employers also value a basic facility with Microsoft Word and Excel.

## Textile design

The breadth of textile design as a discipline means that portfolios will differ substantially between individual designers. Textile design spans constructed textiles, knit and weave, printed textiles, stitched and embroidered textiles, and these specialisms within the discipline may sometimes require different approaches to presentation. However, other than your creative sensibility, the most important factor in determining the nature of your portfolio is the context in which you wish to present it. Textile design most commonly has applications in fashion and in interior design, but practitioners may also work in a craft context, as textile artists, using hi-tech textile applications and even in areas such as automotive design.

### TEXTILES FOR FASHION

Textile designers working in a fashion context need to have an excitement for and an understanding of fashion. This might be indicated by relevant trend-based research in the form of mood boards demonstrating your take on current developments in colour, texture and pattern, and relating this to a particular market and application. Due to the nature of the fashion industry, fabric designs have to be developed in advance of collections; in the case of fabric mills, at least a season ahead. This means that designers must have an instinct for the direction of future trends in textiles.

Print designers and those working in embroidery and embellishment may well work for a fashion label alongside garment designers. In this case, as well as showcasing your designs for pattern and motif, it is a good idea to include images from a look-book or campaign shoot showing the application of your fabrics as garments. It is also of course central to any textile design portfolio to include examples of your finished fabrics, but you may choose to present these separately from drawn designs and research material.

Other more craft-based approaches to textiles will require different types of portfolios. Designer-makers may produce jewellery, badges, napkins or any number of idiosyncratic products. In the case of independent practitioners such as these, a website is often a useful tool for generating interest, while including an online shop can help generate revenue. Designer-makers in textiles may in effect choose to have two portfolios:

24

25

26

27

one which documents their practice and includes developmental and inspirational images, and a smaller folder featuring product images to be presented to buyers, boutiques and potential customers.

## Em Prové, print and graphics designer, Firetrap

'I normally try to start the portfolio with something quite vibrant, something interesting that gives a feeling for my natural hand. I generally structure the portfolio from recent to past, so I'm starting with the season that's just about to go into store.

I think it's good to start a project with a mood board that outlines at the beginning of the season what I'm going to try to achieve with the print. So for example here, an edgy floral print, washed out and using fade-away, it's got an attitude but it's still quite feminine. I have the mood board and then the print on

**Illustrations 24, 25, 26, 27**

*Em Prové's creative approaches to print using collaged, hand-drawn, and painted elements produce fresh and energetic designs. Meanwhile Em's ideas for colour, texture, and motif are developed through sketchbook work (see illustration 27).*

the opposite page. So it's not just about the print, it's about the fashion context as well, and you can see some of the ideas for colour coming from the inspiration images into my design, which gives a sense of my process. As well as showing the work that you have done in the past, I think it's important in a portfolio to communicate a strong identity, which is consistent throughout the portfolio but interpreted in different ways.'

## TEXTILES FOR INTERIORS

Textiles designed for use in interiors need to presented in a way that demonstrates an awareness of this application. For example, designers might include photographs of their fabrics used in an interior context – made up as an upholstered piece of furniture or a screen, used structurally or in lighting. Alternatively, designers can suggest interior applications for their textile designs through illustrations, drawings or even three-dimensional computer renderings included alongside samples of their fabric. As ever, do not expect interviewers to make leaps of imagination: if you want to emphasize the suitability of your jacquards for soft furnishings, you have to find a way of demonstrating that visually.

28

## PRESENTATION

An A3 portfolio is perfect in professional textile design because it is small enough to be easily portable, looks polished and still gives sufficient space to show large designs and fabric swatches. Because textile design is concerned with the touch, handle, drape and texture of fabrics as well as their visual appearance, it is essential to include textile samples in your portfolio. Samples usually make up the majority of a textile portfolio, perhaps backed up with preparatory drawings, inspirational photographs, mood boards and sketchbooks. Print designers will often present their fabric designs un-mounted with a header – a cardboard strip fixed along one edge of the swatch – perhaps including a title and their name. This approach to presentation is particularly well suited for commercial applications such as showing work at fabric fairs. In both knit and weave, however, fabric samples are mounted. The convention is to fix them with double-sided tape along one edge of the sheet, as this allows the viewer to handle the swatch while keeping the folio neat and ordered. Weave designers are more likely to present several swatches (around four) on a single A3 sheet, whereas knit designers more commonly mount one swatch to a sheet. You do however have to be sensitive to scale, so if your design is characterised by large-scale pattern, it would be inappropriate to present it as a small swatch.

9

30

Knit design for fashion sits in a somewhat contested space between fashion design proper and textile design. Because fashion-knit designers are usually designing whole garments as well as fabrics, their portfolios often follow the conventions of fashion design portfolios rather than those of textile design (see fashion section).

# CONTEMPORARY CRAFT

## Introduction

In this post-industrial age, the excitement and blind belief in a world improved and revolutionised by technology has waned. Enthusiasm for the idea of functional, factory-made goods stripped down to their essential components (as proposed by modernist designers) has for many been replaced by a sense that both producers and consumers are alienated from the impersonal, standardised products of mass-production. Equally, as consumer goods are increasingly made in locations far from the point of consumption, there are concerns about the potential environmental and human cost of this model of production. To this end, today's crafts practitioners are finding new and exciting ways to incorporate traditional techniques, vernacular and historical references into their work, while remaining rooted in the modern world. And craft has undergone a resurgence as a return to artisanal techniques has allowed designers and artists to express a more personal response to their practice and materials.

In a sense then, the very notion of contemporary craft is about reasserting the traditional value of lovingly and carefully making artefacts, producing them in relatively small quantities. At the same time it is concerned with allowing the consumer to appreciate and to have a more direct relationship with the physical process of *crafting* an object. In very different ways all the craftspeople featured in this section are engaged in asserting the relevance of craft to the contemporary world. For some that might be by subtly adapting traditional forms, for others by using innovative technologies and processes, by incorporating unusual

materials into their work, or by using new channels of communication (the internet, websites and blogs) to connect to consumers and the public. In the work of furniture designer/maker Gareth Neal, one of the UK's most prominent contemporary-crafts practitioners, this exploration of the relationship between traditional craft and modernity is particularly evident as one of the central concerns in his work.

**Illustrations 31, 32**

*In Gareth Neal's exquisitely crafted furniture, echoes and reflections of the past appear in ostensibly contemporary designs – while high technology is combined with traditional techniques.*

## Gareth Neal, furniture designer/maker

*'As a designer, you think about how you can draw inspiration from previous eras, sometimes by referencing historical "styles". But in this re-emergence of craft that we're talking about it is also interesting to look back at technology and processes that have been undervalued or underused, but which might potentially be exciting and relevant. To really evaluate, perhaps, a Windsor chair and say, well, there's steam-bending, there's the pole-lathe, there's lathe-work, why were those chairs so successful? And how could we use that process and reinvent it to make a really beautiful but perhaps much more contemporary object?'*

**Illustration 33**

*A sample from Gareth Neal's sketchbook, showing some of his design and planning for* George *(a chest of drawers made in oak).*

## BACKGROUND

Practitioners using craft techniques to make one-off and limited edition pieces are typically operating in one of two scenarios: either as designer-makers producing small ranges of products for sale via boutiques, online stores, galleries and craft fairs, or alternatively as fine artists, who incorporate craft techniques in their work while exhibiting, producing work for commission and perhaps even operating as an artist in residence (clearly, some craftspeople may make work which straddles the design/applied art/fine art divide). Similarly, practitioners may have a traditional training in craft (in cabinet making, studio ceramics, silversmithing, or hand-weaving, for example), they may have studied in a fine-art context and become interested in appropriating craft techniques, or they may have come from a more industrially oriented background, in product or textile design, for instance. What unites these apparently disparate

practices is a concern for lovingly made artefacts and products which contain significant elements of hand-making or hand-finishing. Many practitioners are excited by traditional craft techniques in their own right, while others combine these techniques with contemporary technologies or with unusual approaches and materials to produce innovative results. For example, jewellery designer Sarah Kelly uses intricately pleated, folded and laser-cut paper to create her distinctive pieces, which she markets under the label *Saloukee*.

# Sarah Kelly, jewellery designer/maker

*'Whilst making maquettes in paper to create jewellery, I realised I loved working with the sensitivity of the material, much more than I liked the very expensive metals and stones I had been traditionally trained with. Today, my work is still directly influenced by historical and contemporary couture fashions and in particular, by material manipulation techniques. I find problem solving, advancements in technology, and the engineering and combination of contradictory materials very exciting and influential.'*

**PRESENTATION**

Sarah Kelly has gone to great lengths to create a strong and visually effective identity for her brand *Saloukee,* including commissioning a brand designer to tailor a website, logo and various promotional materials to her needs and specifications. The result is an extremely coherent and professional brand identity which nevertheless doesn't threaten to overwhelm or distract from images of her work. Sarah Kelly says of branding her work:

*'I worked long and hard with a brand designer to get the appropriate visual aesthetic to represent my company. Everything I now send out to clients, present online or in promotional material, I try to brand in the same way, with a clear, coherent and beautiful visual aesthetic (using the same colour, font, imagery and*

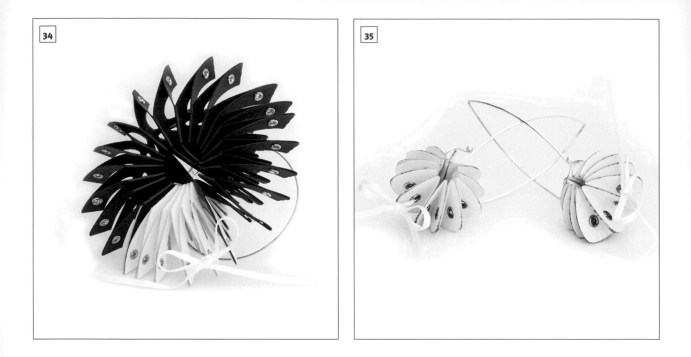

Saloukee / Identity Concepts
Business cards

A / Black + silver print

# SALOUKEE
## DESIGNED BY
## SARAH KELLY

SALOUKEE.COM
+44 (0)7981 123 456
SARAH@SALOUKEE.COM

B / Black card with laser-cut type (no printing). I like this!

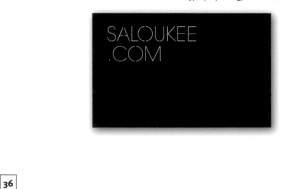

SALOUKEE
.COM

You could also print your details on the back if you wanted...

logos etc). My aim in doing this is that as my brand grows it will be visually recognisable and represent the correct connotation of sophistication, linking directly with what I aim for in my jewellery.'

As Sarah suggests, one important consideration when developing a website, or other promotional materials, is to ensure that you use presentation to frame your work appropriately. In Sarah's case the brand identity serves to reinforce the complex, refined qualities of her paper jewellery. More generally, designers and craftspeople may need to be sensitive to presentational tropes in a variety of situations. Ceramicist John Butler uses wood firing to create pottery informed by tradition which retains a modern sensibility. In his case, presentation is important both in framing his practice and in connecting with his consumer.

**Illustrations 34, 35, 36, 37**

*For Sarah Kelly's* Saloukee *brand, online and printed promotional materials work together to create a coherent visual identity. Jewellery design: Sarah Kelly, photography: gemmadewson.com and branding: nickallencreative. com.*

## John Butler, ceramicist making wood-fired pieces

'One of the chief means of promoting my work is through ceramics shows. In this context presentation is extremely important as it affects not just whether people notice your work, but also their perception of it. When I started doing shows I used to display everything on slabs of wood – the problem with this was the work didn't stand out from the wood, and the look was too "country cottage". Now I use simple black-lacquered cube shelving to display my work. Against this background the qualities of the material are much easier to appreciate and the subtle colours stand out. It's also about presenting the work in a modern context while still implying a domestic space. Alongside the work, I also present photographs of the firing process at shows and events. I started off by presenting these as printouts in plastic sleeves, but using an online book creator makes it so easy to produce a professional-looking, captioned, hardback book of photographs – and this is what I use now.'

As John points out, presentation can be used to influence the way that consumers understand and respond to work. By presenting his beautiful, traditionally crafted pottery in a context which suggests a clean modern

interior he is able to highlight the inherent qualities of his ceramic pieces: the organic textured surfaces, the subtle nuance of hue and tone, and the hand-crafted form of the pottery. At the same time, his use of lacquered display units, implying a modern domestic space, indicates

the way in which his traditionally crafted ceramics can be integrated into a contemporary interior environment. Also vitally important is the documentation of the process of building the kiln and throwing and firing pots, which John includes alongside his exhibited work and on his website. These images allow the viewer to connect in an immediate and personal way with the making of a vessel, so crucially important in a process-driven discipline like studio ceramics.

Many crafts practitioners find exhibitions to be an important way of promoting their work and of driving sales. As John Butler indicates, presentation of your work in the context of an exhibition as well as the preparation of appropriate promotional materials are key to attracting the attention of the public and building a reputation in your field. Equally, selecting the right shows is important, as you are likely to invest considerable time and resources in making work and preparing for exhibition. Competitions are also a good way of building your profile: even if you aren't one of the winners, getting your work in front of a panel of judges is a good way of gaining recognition among influential people. Furniture designer/maker Gareth Neal talks about the importance of promotional material:

'If you're doing tradeshows regularly, you need to turn up with brochures, postcards and handouts because they're physical things, they live in the real world and people will take them home and remember you. Postcards are always a great cheap way of doing it. I've done many different shows, exhibitions and events and through trial and error worked out which ones were most worthwhile for me. Certain shows are for selling and don't attract much press, other shows will pay for themselves through the interest they generate. 100% Design, for example, won't give you immediate revenue in terms of sales, but will generate PR and press attention. The other thing is perseverance: I had a solo show last year at a gallery, which was very successful and which they really liked, but I had applied in the two previous years to the same gallery and been turned down. So it's worth trying again as things don't always happen at once.'

Clearly then it's essential for crafts practitioners to keep on top of which shows, galleries and prizes are generating interest, and which might be relevant to them. As an independent practitioner, it is always useful to be aware of

**Illustrations 38, 39, 40, 41**

*John Butler's work articulates the organic nature of the materials he uses as well as celebrating the controlled unpredictability of the making and firing process, resulting in unique and individual ceramics. Images documenting the firing of John Butler's pottery (see illustrations 40 and 41) provide consumers with a direct connection to his practice.*

developments in your field and to be in touch with other up and coming craftspeople, artists and designers. To this end there are a number of organisations and events dedicated to the promotion of craft, applied art and design in the UK, which it is useful to be aware of: exhibitions and events of note include:

Origin   www.originuk.org

Design Week   www.designweek.co.uk

100% Design   www.100percentdesign.co.uk.

While galleries and organisations of interest include:

Contemporary Applied Arts   www.caa.org.uk

Crafted   www.crafteduk.org

Hidden Art   www.hiddenart.com

Crafts Council   www.craftscouncil.org.uk.

In addition to these, regional arts and craft organisations are often keen to support local practitioners.

Inevitably, websites and online portfolios are an invaluable resource for independent designer/makers. Indeed, all of the craftspeople interviewed for this section of the book cited their websites as being essential – both as a key point of contact for consumers, peers and interested members of the public, and as their most up-to-date and important portfolio. It is increasingly likely that a designer/maker will have a physical portfolio as such (although as we have mentioned he or she may well use brochures and booklets in the context of an exhibition). Instead a good online gallery with carefully, and if at all possible, professionally taken photographs against a white or neutral background often serves as the most accessible and relevant form of documentation. For sending high resolution images for press and publication, practitioners often use file-sharing sites such as www.yousendit.com, while PDFs are a common way of emailing images of recent work to interested parties when print quality is less critical. Another important means of documenting work in a perhaps rather more immediate and personal way is by using a blog. This allows practitioners to keep followers up to date with any exhibitions or other developments in their practice, ae well as upload inspirational images, comment on the work of others that they admire and engage in a dialogue with their followers. In a sense, the blog functions almost as a digital, interactive sketchbook.

# FINE ART: PORTFOLIOS IN CONTEMPORARY ART

## Presentation

One of the most fundamental requirements of a portfolio is that it should help the viewer make sense of your work. Portfolios in contemporary art practice tend to be shorter than in design, sometimes containing only a handful of particularly important images, perhaps presented together with written documentation and recent exhibition catalogues. This convention is understandable as artists often spend weeks or months producing an individual work. So, given that you may be presenting a relatively small selection of work, it is essential that the images included in your portfolio are carefully chosen and of high quality. In today's digital world, it is unlikely that you will be presenting a portfolio 'cold', without the gallery or interviewer in question having seen a previous submission of work, for example in the form of a PDF. As they will probably have already viewed your work either online or in an exhibition, the function of your portfolio is then in effect to provide a basis for a conversation about your practice, your previous experience and your plans for future work. At the same time, the portfolio form allows you to draw out aspects of your work that are more difficult to appreciate in other settings and to contextualise your practice, perhaps by showing links between discrete works and projects.

## Diana Kaur, independent curator and editor, Stockholm

'In my experience, having seen many portfolios in my professional life, I think many of them are just horrible; they're sloppy. They present too much information, poorly edited information, bad images, poor quality low-resolution images, stuff as basic as that. You can't see what an image is, you're asking, "Where's this from?" You're struggling to understand work at a very basic level.'

There are many different ways of presenting work in an accessible two-dimensional form: in a conventional portfolio folder, in a bound book or in an archive box, for example. Approaches to presentation may vary,

**Images 42, 43, 44, 45, 46**

*Often produced using found objects, as well as home-made oil paint and varnish, these energetic mixed-media works by Lee Broughall –* Hostilities on the Coastal Perimeter, Telephone Booth, *and* Pillow *– illustrate the artist's dynamic and painterly approach, while photographs (illustrations 45 and 46) indicate how his research and photography informs his painting in the studio.*

but on the whole, artists seek to present images fairly neutrally, against a white or off-white background that distracts as little as possible from the content of the work. As Diana Kaur suggests, it is essential to pay careful attention to detail even when presentation is relatively simple. Artists should always use high-quality photographic or digital prints, carefully consider the scale of the prints used and be deliberate about the images they choose. As we have previously discussed, apparently superficial decisions regarding presentation can have a significant effect on how you are perceived. Therefore, if you favour a rough and immediate approach to documenting your work, it is important to make clear that this is a deliberate decision rather than a lack of care. It can be helpful to find a simple and inconspicuous way of including the work's title, medium, dimensions and perhaps a brief explanation on each page, again helping to contextualise and make sense of the pieces documented. If you work across different media or produce works of very different scales, it can be useful to find ways of grouping pieces to relate them thematically, thereby implying a sense of continuity between the various works.

**DOCUMENTING SPACE AND CONTEXT**

## Alastair T. Willey, artist and curator

'Some artists will put on exhibitions in cheaply rented spaces primarily with the aim of documenting their pieces in situ. And this is an important issue when it comes to compiling documentation of your work, whether that's for a funding application or showing your work to a gallery or institution. It's that extra dimension of seeing a work in a space, how it interacts with that space and also to gain a sense of scale. A Photoshopped image on screen, where you don't see the edges of the canvas or the space around the sculpture, is a limited way of showing and documenting your work.'

As Alastair T. Willey suggests, when seen as decontextualised images, work can lose a sense of that important additional element – space. Knowing whether a painting is five metres or five centimetres high is important in order to understand the work in question. Indeed, not only can scale alter the experience of viewing a work but also the way it communicates ideas and meaning. Perhaps even more than paintings, three-dimensional pieces such as sculptures and installations are inextricably linked to the spaces in which they are shown, and the viewer relies on that context to make sense of the work. Galleries and funding bodies will therefore be interested in how you choose to stage exhibitions, the kinds of spaces you have deemed suitable for your work and how the pieces relate to their surroundings. Installing a sculpture in a white cube naturally lit from above is going to achieve a remarkably different effect to showing the same work in the crypt of a church or in the open air, and these choices are clearly relevant to how your work will be perceived.

**PORTFOLIOS IN ARTS EDUCATION AND COMMUNITY ARTS**

The way artists present themselves and their work will often change according to the needs of the organisation they are approaching. Artists operating in an educational or community context are interested in communicating skills beyond their own abilities in making interesting

art: they also need to be able to convey ideas in an accessible way to non-artists and be able to lead groups in producing practical outcomes. When galleries or arts organisations recruit workshop leaders or artist educators, they are looking for artists who have experience enthusing others and enabling those who don't have a background in art to engage with concepts and activities relating to contemporary arts practice.

Typically, those applying for positions within a community arts or arts educational setting will contact galleries and other organisations with a covering letter, a simple biographical CV and a link to their website. Interviewers will be interested in seeing not only the artist's own work on a website but, perhaps more importantly, evidence of projects completed with others – for example, photographs of a workshop in progress together with examples of outcomes of the activities organised. For this reason, it is a good idea to document any community or educational projects that you are involved in, including photographs of the participants making work and images of

**Illustration 47**

*This page from the portfolio of Gemma Walker, forms part of a series of images illustrating the range of community arts projects in which she has been involved.*

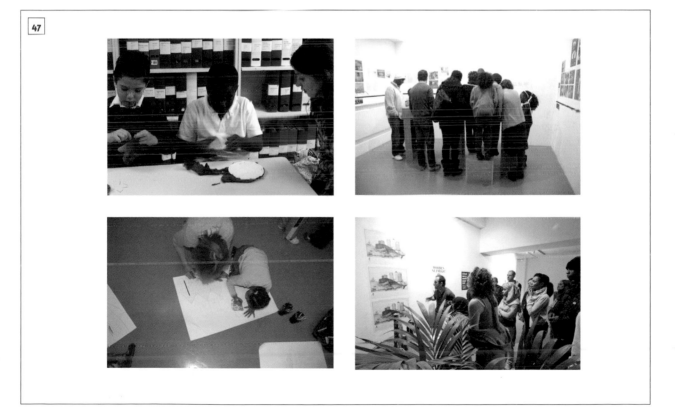

47

the finished product. These images might well be supported by written documentation or a brief clarifying your aims and approach. They will also be interested in seeing links between your own practice and the way you engage with others, such as young people or community members. This may be quite straightforward if your practice is by nature collaborative, or it may be a matter of demonstrating how techniques and approaches from your own practice inform your teaching or workshop projects.

In a teaching context in particular, employers are likely to be interested in artists who are able to use a range of processes in their work. Applicants with a variety of technical and media-based skills are attractive because of their potential ability to deliver a broad curriculum. For this reason, when presenting your own work or evidence of previous teaching experience, it can be useful to talk about how you might use various processes such as printmaking, photography or digital manipulation, for example, to engage students with ideas in art and design, or with particular aspects of the curriculum.

**PROPOSALS**

## Dr Andy Charalambous, artist

Andy Charalambous is a student of fine art with a background in engineering and science.

'Each funding body you approach will have different sets of criteria that they use to gauge the validity of your project. So you can't write a proposal and think that it can be sent off to ten different bodies. You have to tailor each proposal to fit the specific aims or aspirations of the charity or council in question – you have to look at their website and documentation and find out what they're there for. It's also about couching your project in terms that the funding body will understand. So for a recent project that was about bringing together expertise in science and in art, the Arts Council had to able to see what the benefits were to the arts community. At the same time, as a curator and co-ordinator I couldn't prescribe what the other artists I was working with were going to produce – I

*couldn't constrain them in that way. What I could do was describe the work
they had made in the past, suggest what their current line of thinking was, and
indicate what kinds of works they might make during the project.'*

An ability to write interestingly and informatively about your work is an
inherent aspect of contemporary art practice: many artists say they spend
almost as much time writing proposals and artist's statements as they do
producing new work. It is in the nature of being an artist that at the same time
as producing and exhibiting work, you will also need to be planning new
projects and new collaborations, and constantly be liaising with galleries,
project spaces, other artists and funding bodies. As Andy Charalambous
suggests, this means that you have to develop an ability to explain and
justify your practice, and at times focus this explanation in a particular way
to suit the gallery or organisation with whom you are in contact.

Websites and portfolios are also likely to feature texts that help to
contextualise an artist's visual, performative or time-based work. As well
as being useful for viewers of the work, it can be useful for the artist to
verbalise and explore in writing what his or her art is about. Depending
on your individual sensibility, you may wish to engage with art theory,
philosophy or literature in your writing, but equally, you may want to
talk about how your own experiences or sense of aesthetics influence
your practice. While it may sometimes be advantageous to emphasise
specific aspects of your work in particular contexts, a proposal should
fundamentally be an enlightening and engaging reflection on your
artistic practice: it should help you and others make sense of your work,
and suggest new possibilities and departures for you as an artist.

**ESTABLISHING YOUR CREATIVE PRACTICE**

# Diana Kaur, independent curator and editor, Stockholm

*'I worked with an artist-run space called ak48, which ran for about five years.
It started because a group of newly graduated artists were missing exactly the sort
of platform we're talking about: the bridge between the art academies, commercial*

galleries, state-funded institutions and beyond internationally. There just wasn't anything at that point, at the beginning of 2000, in Stockholm. There was nothing; it was a void. So these young artists, new graduates from the academies in Stockholm, they got together and they created that platform for themselves.

So if there isn't a platform for you, then don't be afraid to create one, and maybe you can do that within the framework of another institution for a while. These people needed studio space anyway, so they shared the studio space and rebuilt it. They set some space aside to create a white cube, and there we had shows for five years, and seminars and screenings. Many Swedish artists who are doing quite well today had their first show with us. Of course, at that point they didn't get paid, we didn't get paid, nobody got paid, but they were able to have a show on an existing platform. Press and people would come to the shows, so it had an infrastructure — not an economy at that point, but the infrastructure was there. This is what we had to offer, but then we had to create it ourselves.'

The process of establishing your practice as an artist is notoriously difficult, and the art world can seem like a series of exclusive and impenetrable clubs. But as Diana Kaur suggests, even if there are no obvious opportunities to exhibit and disseminate your work, it is nevertheless essential to stay active, to continue making work and to engage with other artists, critics and theorists in a positive and creative way. Keeping in touch with other artists is important in the first instance, collaborating with your peers where possible. Putting on self-funded shows and even producing your own catalogues and documentation are good ways of continuing to enrich and expand both your portfolio and more importantly your practice as an artist.

## 3D: PORTFOLIOS IN INDUSTRIAL DESIGN, INTERIOR DESIGN AND ARCHITECTURE

### Industrial design: product and furniture design

#### CONCEPT

Industrial design includes the design of a wide variety of three-dimensional forms, including furniture and consumer products. It can

also include the design of systems relating to people's interaction with technologies (interface design), and is increasingly likely to be engaged with ecology and sustainability (sustainable design). Contemporary industrial design is focused on behaviour, function and the exploration of three-dimensional form. Practitioners in the field are often inspired by considering how people interact with spaces and objects and by solving problems, be they problems identified by a company in relation to one of their products or issues arising in our everyday lives.

Since industrial design is such a broad area, graduates may go on to work in a variety of contexts: in bespoke high-end furniture design, designing shop fittings or working for a manufacturer of consumer electronics. Inevitably, as you become more experienced as a practitioner your portfolio will become increasingly specialised in certain aspects of the discipline. While it is desirable for a graduate portfolio to demonstrate a range of skills and abilities, it is equally important that the portfolio conveys a strong sense of identity. This clear definition of your personal style and approach will help you to direct your design practice. So if, for example, your work has a quirky, decorative, humorous quality, that might incline you towards designing furniture, crockery and tableware, and away from designing consumer durables. While function and problem solving are important in industrial design, there is also space for approaches that are primarily aesthetically inspired. Furniture and product design absorb influences from related areas such as fashion and interior decor, and designers sometimes explore ideas around decoration, beauty, visual semantics and humour in their work.

## PRESENTATION

Since problem solving is key to the practice of industrial design, employers in the field want to see portfolios that identify creative and innovative solutions to a range of briefs. To this end, portfolio projects should be presented in a way that incorporates an explanation of the concept, your research and the rationale behind your design. Projects often start with a product shot – either a photograph of the product, an illustration or a 3D rendering. The role of this image is twofold. Firstly, it

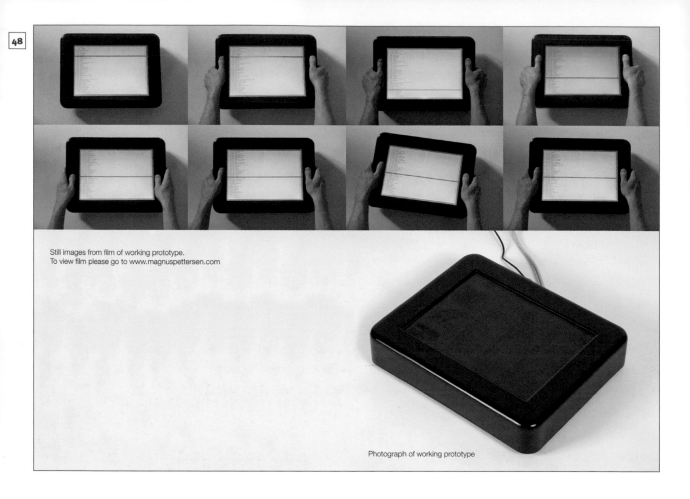

Still images from film of working prototype.
To view film please go to www.magnuspettersen.com

Photograph of working prototype

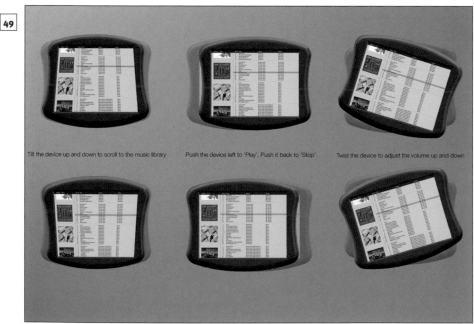

Tilt the device up and down to scroll to the music library

Push the device left to 'Play'. Push it back to 'Stop'

Twist the device to adjust the volume up and down

## Illustrations 48, 49

*Magnus Pettersen explores his concept for a contemporary stereo system employing interactive technologies using prototyping and computer-generated imagery.*

should be strong and visually arresting enough to grab the interviewer's attention. Secondly, it should make clear the concept and function of the product in question, perhaps by including multiple views from different perspectives or by showing figures interacting with it. Demonstrating an ability to convincingly visualise design concepts is valuable, as employers may well require candidates to draw up proposals for clients, whether by hand or using software such as AutoCAD.

## PROCESS

The ability to develop concepts in three dimensions is an important aspect of industrial design. In reality, products are designed in an iterative process, and it is often technically impossible to resolve ideas on paper without some three-dimensional experimentation and trials with materials. Finding a way of indicating how a concept has been developed, for example by documenting your process of making and refining maquettes, demonstrates a rigour to your design approach. Working designers often use simple card and paper models to help them communicate concepts to colleagues and clients. In the same way, including examples of working drawings helps others gain insight into your design process, how you work through and think through problems. Interviewers often find developmental work particularly interesting, so you should try to communicate the story of the product's development effectively, from initial concept to final design.

## ATTENTION TO DETAIL

While graduate designers often have exciting and original ideas, a professional attitude to product design is defined by scrupulous attention to detail. Whether you are presenting a concept illustration or documenting an existing product or a piece of furniture you have designed, it is essential to indicate that you have thought about the whole object, viewed from every angle. It is equally important to demonstrate that you have carefully considered the details of how the product is made, including features such as the radiuses of joints, carpentry, moulding and other manufacturing

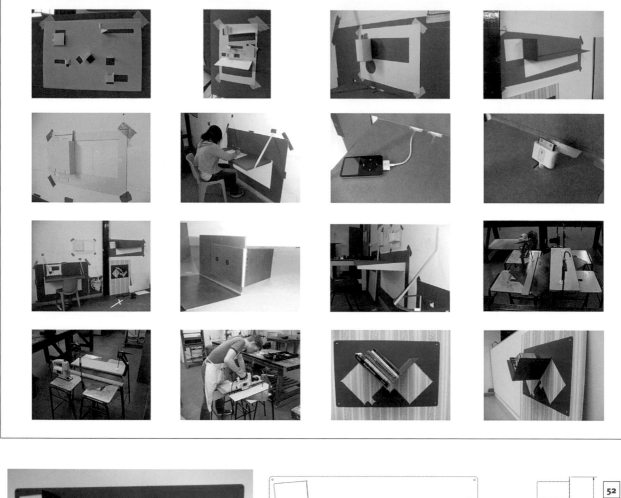

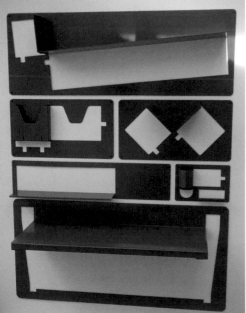

processes, thereby indicating a knowledge of design archetypes and semantics. In documenting your design, you should attempt to give a sense of the broad concept and at the same time demonstrate your ability to produce a rigorously resolved and considered product by including close-up views and detailed plans with measurements.

Employers will also be looking for a range of contemporary and traditional skills in your portfolio. Because the fundamentals of industrial design lie in the manipulation and testing of materials, they will value evidence of experience working with a variety of materials and manufacturing processes. For more experienced professionals, this is likely to take the form of realised projects produced in an industrial context. However, students and graduates can indicate knowledge of manufacturing and materials by documenting the process of experimentation and make in the workshop.

A proliferation of computer-aided design software has opened up a wealth of possibilities for industrial designers. Impressive three-dimensional visualisations and detailed scale drawings can be completed accurately and relatively quickly using programs such as Vectorworks, AutoCAD and Microstation. Meanwhile 3D printers and rapid-prototyping machines allow designers to see solid representations of their designs produced from an onscreen rendering. Graphic design programs such as InDesign, Photoshop and Illustrator are also useful for achieving professional presentation and layout. Knowledge of one or more 3D visualisation programs, as well as an ability to use more general graphics software, is clearly a useful and marketable skill for a product or furniture designer. Nevertheless, the core of industrial design practice lies in more traditional conceptual, making and hand-drawing skills, which CAD should support and enrich rather than replace.

As indicated in illustrations 48–52, a combination of text, illustrations and photographs, conceptual sketches and technical drawing can be used to explain and sell your ideas successfully. Structuring your presentation according to a specific format, perhaps including a repeated graphic device, can be a good way of lending your portfolio coherence. Thorough presentation makes clear that a brief has been researched, a concept thought through and the aesthetic and function of a design resolved to a high degree.

**Illustrations 50, 51, 52**

*Magnus Pettersen illustrates the process of designing, developing and producing an 'office space' product manufactured from a single piece of sheet metal. The photographs indicating the process provide an insight into Magnus's approach as a designer, as well as the organic development of the product.*

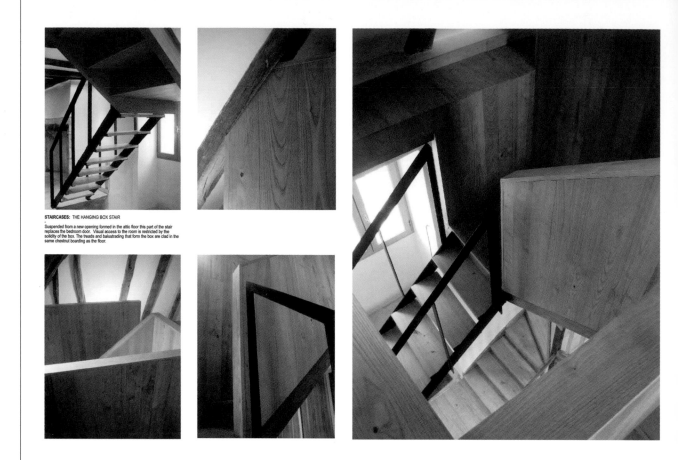

**STAIRCASES:** THE HANGING BOX STAIR

Suspended from a new opening formed in the attic floor this part of the stair replaces the bedroom door. Visual access to the room is restricted by the solidity of the box. The treads and balustrading that form the box are clad in the same chestnut boarding as the floor.

**Illustration 53**

*Architect Mark Marshall's interior images from a private commission demonstrate a sophisticated and considered use of materials.*

## INTERIOR DESIGN AND ARCHITECTURE

Interior design is sometimes confused with interior decoration – a very different discipline concerned with dressing and furnishing interiors. In contrast, interior design, sometimes also known as interior architecture, deals with the structural, functional and aesthetic aspects of interior spaces as well as the behaviour and experiences of those inhabiting and using these spaces. Interior design and architecture are closely linked disciplines, and it is sometimes difficult to demarcate where one begins and the other ends. Clearly, architects do not only design the exteriors or facades of buildings, as the very process of designing an external structure requires internal space to be created. Architects may also sometimes undertake projects that involve intervening in existing

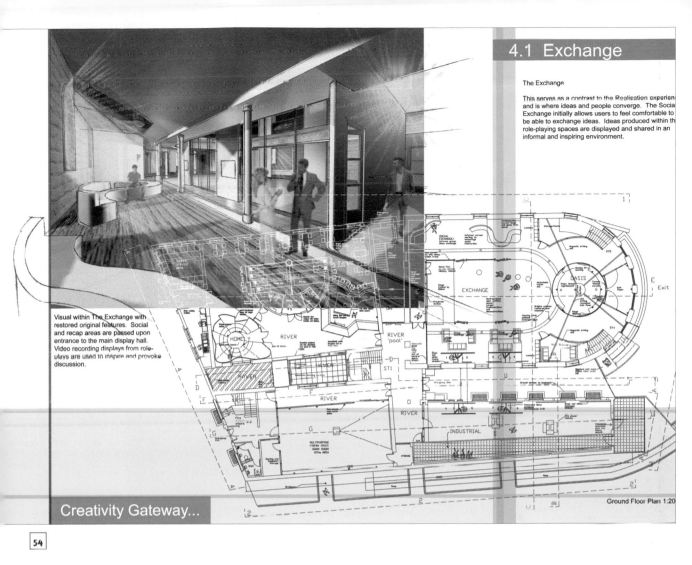

The Exchange

This serves as a contrast to the Realisation experien and is where ideas and people converge. The Socia Exchange initially allows users to feel comfortable to be able to exchange ideas. Ideas produced within th role-playing spaces are displayed and shared in an informal and inspiring environment.

Visual within The Exchange with restored original features. Social and recap areas are passed upon entrance to the main display hall. Video recording displays from role-plays are used to inspire and provoke discussion.

Creativity Gateway...

Ground Floor Plan 1:20

54

**Illustration 54**

*In this presentation from the BA portfolio of interior designer Chloe Sharpe, carefully considered technical information is lifted by a confident visualisation of the designed space, combining hand-drawn and computer-generated imagery.*

structures or refurbishing interiors, which might equally be undertaken by an experienced interior designer. Given the shared methodology of the two disciplines, the following section is relevant to both interior design and architecture, irrespective of the terminology used.

## SKILLS AND ABILITIES

When interviewing recent graduates, employers are unlikely to be looking for expertise in a particular field of architecture, as this tends to develop from professional experience. However, practices will be looking for good presentation skills and beautiful drawing, as well as an ability

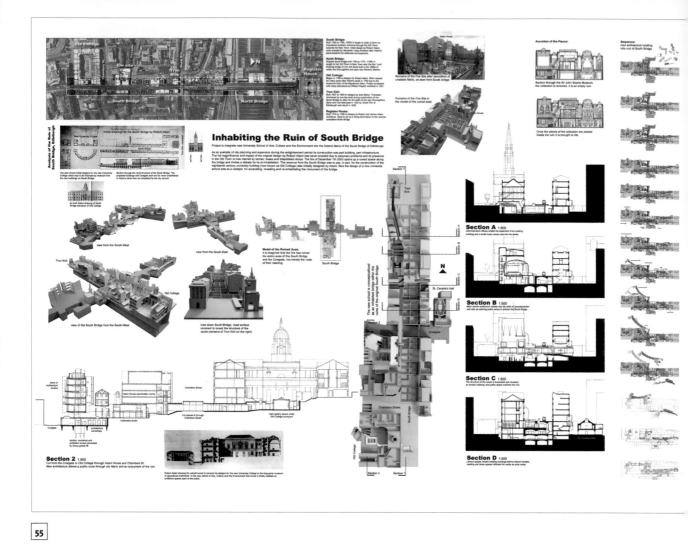

**Illustration 55**

*This presentation produced by architect Mark Marshall for a student competition demonstrates a wealth of information and detail in the form of plans, photographed models, elevations and sections. Note the carefully designed page and the considered use of type and photography.*

to talk about your work intelligently and reflectively. Despite the use of computers, crafted hand-drawing is still considered a core skill and is a useful addition to your portfolio, as it communicates something of your personal approach and sensibility.

Evidently, architecture and interior design are disciplines in which ideas around three dimensional form and space are of key importance. It is very sensible, therefore, to demonstrate an ability to produce imaginative experimentation in 3D in your portfolio. Experimentation may include very simple paper models made as an initial response to a brief, as well as more complex models produced at the later stages of a project. Good model-making skills are valuable asset, and it is possible that a practice might take on a candidate who is particularly strong in this

area with a view to using his or her skills in the context of commissions and competitions. More generally, it is important to demonstrate an awareness of appropriate construction techniques in your work, and to indicate a careful consideration of materials in your design. For more experienced practitioners, this knowledge may come from professional and even hands-on experience, but students can demonstrate an understanding of materials by presenting photographs of models they have made and where relevant experimentation with durable materials such as oak, MDF or cast concrete. An understanding of these kinds of materials not only allows you to draw and detail accurately, but also to convey information effectively to builders and craftsmen. Equally, particularly in more interior-focused work, an awareness of electric, lighting, plumbing and ventilation systems helps to demonstrate thoroughness in your design work.

CAD packages are becoming increasingly important and interviewers may well be looking for applicants who are able to use a range of programs to a high standard in order to produce plans and three-dimensional visualisations. Commonly used programs include Vectorworks, MicroStation and AutoCAD, especially for more two-dimensional work, and Rhino and 3ds Max for three-dimensional modelling and rendering. Practices may also use less specialist programes such as SketchUp to produce initial visualisations for a project at speed. Employers are often from a generation that wasn't trained in the latest computer packages, so recent graduates and even students are often quicker and better at using CAD tools than their bosses, although they clearly won't possess the same level of experience in other areas.

## PRESENTATION

Portfolios made up as bound books or spiral-bound leather folders are a standard way of presenting your work in architectural practice. As a more experienced architect or interior designer, you might well choose to bring individual reports containing plans, elevations, sections, a design and access statement seperately , rather than condensing this work into your portfolio proper.

56

**Illustration 56**

*An original concept image by architect Mark Marshall uses collage, paint and photography to create a dynamic inspirational composition.*

Verbal presentation skills are vital for architects and designers: interviewers want to see candidates who can explain their work in a strong, positive and convincing manner, as they will need this ability to communicate their ideas to clients and colleagues. It is important to be able to convey concepts and demonstrate the rationale for your decisions. In the highly competitive world of architecture and design, it is also essential that candidates convey passion and dedication to their craft. As ever, being enthusiastic and motivated are as important as possessing a range of technical skills.

When viewing a portfolio, employers are trying to get a sense of an overall proposal and concept, the way in which broad design and structural issues have been dealt with as well as the architect's take and opinion on the brief. A concise, effective way of communicating the initial

# INDEX

access course 94, (*see also* foundation course)
agents/agencies 15, 110, 126
architecture 30, 31, 154-159
art/fine art 18, 35, 38, 45, 48, 49, 74, 81, 90, 91, 142-149
artist's statements 18, 147
arts education 18, 90, 91, 100, 144-146

BA/degree 75, 81, 82, 86, 87, 96–98
blogs 55, 56, 67
branding 22, 23,136, 106, 107

CAD 20, 153, 157
ceramics 81, 138
community arts 18, 144-146
computer programs 20, 60, 63, 110, 126, 153, 157
craft 20, 28, 127,132-142,156
CV 50–54

developmental/preparatory work 21, 40, 41, 72, 85, 86

exhibitions/galleries 15, 48, 139, 141

fashion 13, 41, 51, 82, 77, 78, 86, 121–6
foundation course 69, 70, 77, 78, 85, 89, 94, 95
furniture design 16, 17, 41, 133, 134

graphic design 20, 21, 22, 23, 38, 63, 105-122

illustration 32, 33, 35, 46, 47, 55–61, 113-116
industrial design 16, 17, 41, 148–153
interior design 30, 31, 85, 154–9
jewellery design 9, 135, 136

layout 30, 31, 32, 33, 58, 59, 61, 41, 88, 90, 123, 136

mood-boards 21, 77, 78, 86,123, 122

order/ordering 34, 35, 87, 88

painting 72, 140, 144, 158
PDF 44, 63, 64
photography 90, 100, 117–120, 141
portfolio folders 26, 27, 43
postgraduate 69, 79, 90, 91, 93, 99–100
product design 14, 42, 43, 148–153 (*see also* industrial design)
promotional materials/packages 44–51, 139
publishing 115, 116

sculpture/installation 35–7, 48, 49, 74, 81, 85, 144
sketchbooks 21, 74, 83, 129, 134 (see also developmental work)
skills/core skills 20, 80-84

textile design 28, 29, 127-131
typography/text 30-32, 33, 38, 54, 55, 70, 110

websites/online portfolios 35, 55–62, 64, 67, 136, 141, 142

## Pictures & Quotations

Aitken, Catherine 29
Bennett, David 115
Bicocchi, Agnese 46, 47, 61, 113, 114, 116
Bowstead, John 69
Broome, Carly 110

Broughall, Lee 140, 141
Butler, John 137, 138
Charalambous, Andy 74, 81, 146
Dorey, Ralph 18, 48, 49, 51
Dyer, Lauren 126
Edwards, Kathy 124, 125
Elliott, Kirsten 20, 21, 22, 23,111,112
Foster, Andrew 69, 93
Golmohammadi, Lili 54
Haigh, Jessica 130, 131
Helliwell, Jayne 32, 33, 115
Highcazony, Bonnie 122, 123
Kaur, Diana 60, 143, 147
Kelly, Sarah 9, 135, 136
Law, Clare 97
Marshall, Mark 154, 158
McCauley, Christine 75
McCauley Bowstead, Jay 27, 51, 77, 78, 86
McCauley Bowstead, Theo 72, 83, 89
McKay, Mark 14, 17, 41
McLaughlin, Zack 58, 59, 61
Neal, Gareth 133, 134, 139
Pearson-Howes, James 118, 119, 120
Pettersen, Magnus 16, 148, 152
Prové, Em 128, 129
Renfrew, Elinor 82, 87
Sagoo, Manveer 70, 71
Sargeant, Rhonda 85
Sharpe, Chloe 30, 31, 40, 52, 53, 155
South, Marina 12, 13, 41
Southgate, Emma 43
Theobald, Charis 63, 106, 107, 108
Vincett, Paul 35, 55, 56, 57
Walker, Gemma 90, 91,100, 145
T. Willey, Alastair 36, 37, 45, 144
Winters, Lloyd 38
Wooley, Janet 79

inspiration and motivation for a project is to use a 'concept image'. This could be an abstract model which was the starting point to your design, or even a painting or photograph you have produced. Its role is to visualise abstract concepts that have informed your approach such as 'isolation' or 'interconnectedness', and to suggest formal and structural ideas for your design. Equally, this sort of image can demonstrate an inventiveness and freedom of approach more creative employers will value.

Materials for college competitions and presentations as well as presentation sheets in the professional world will often be at a very large scale, A1 or even larger. When shrinking down presentation sheets and plans for your portfolio, it is important to ensure that the image still reads well and can be made sense of at a smaller scale. Alternatively you may wish to edit your portfolio by isolating and recombining various elements from an original presentation. Interviewers are not going to have time to decipher all the detail and planning of each project in your portfolio, but they will want to see that all relevant issues have been resolved and considered. CVs in interior design and architecture should always contain a visual component, especially at the beginning of your career. Images help reinforce your skills and experience as well as communicating something of your sensibility as a practitioner.